IMAGES
of America

ST. JAMES

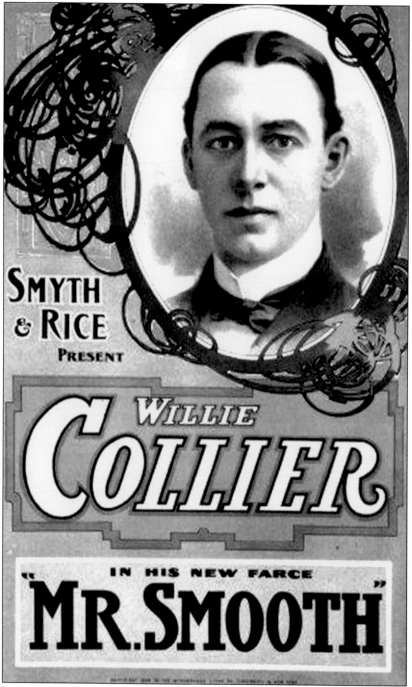

WILLIE COLLIER AS MR. SMOOTH, C. 1899. Local resident and vaudeville star Willie Collier looks dapper in this advertisement for his new comedy *Mr. Smooth*, which premiered at the Manhattan Theater in September 1899. It was one of his earliest mature roles. The *New York Times* noted that Collier was "as funny as ever, in his imperturbably grave way."

On the cover: Please see page 108. (Author's collection.)

IMAGES
of America

ST. JAMES

Geoffrey K. Fleming

ARCADIA
PUBLISHING

Published by Arcadia Publishing
Charleston, South Carolina

Printed in the United States of America

Library of Congress Catalog Card Number: 2006928531

For all general information contact Arcadia Publishing at:
Telephone 843-853-2070
Fax 843-853-0044
E-mail sales@arcadiapublishing.com
For customer service and orders:
Toll-Free 1-888-313-2665

Visit us on the Internet at www.arcadiapublishing.com

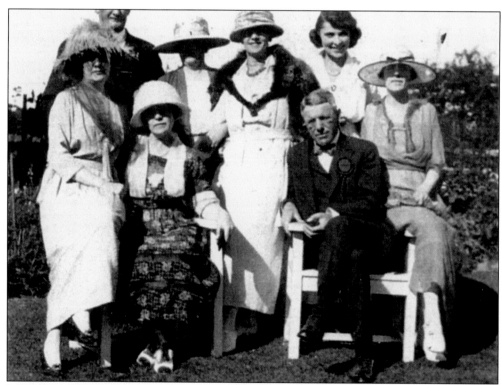

IN THE ROSE GARDEN, C. 1918. Members of the Thornton family pose for a picture around the time of World War I in the garden at Villa Memo. This picture includes images of William D. Thornton (1870–1953) and his sisters Adelaide (1872–1963), Lucile (1874–1949), Caroline (1875–1953), and Frances (1879–1957).

CONTENTS

ACKNOWLEDGMENTS

This is a book that I have wanted to assemble for a very long time. Having been raised in St. James, I have always had a great love for the history of our once small community. It was instilled by my grandparents, Thomas and Kathleen Fleming and Louis and Josephine Mautone, who all lived locally, and by *Tante* Kaethe Gessmann, our neighbor when we lived at 275 Jefferson Avenue.

No publication could hold the number of images of St. James that I would like to have included. Only so many images and so much information will fit into one book, and for this book, I have chosen to include enough descriptive text to adequately illuminate the subject: the history of St. James. Even so, the book does not cover the whole history but rather looks at the time period from about 1860 to 1960. In doing so, it presents wonderful old images that are often quite fascinating and that show scenes not recalled by most residents living today.

The pictures come from a number of sources, both individual collections and organizations.

Credit is due to the University of Texas at Austin's Harry Ransom Center's Minstrel Collection, the University of Florida's Ringling Collection of 19th Century Actors and Actresses, the St. James Lutheran Church, the St. James Sons of Norway Hall, the Smithtown Public Library's Handley Collection, and the Smithtown Historical Society archive.

Credit for generous loans of images is also due Cathy Carracciolo, Conchita Thornton Marusich, members of the Thieriot Family, Brigid Bisgood Galusha, and Mrs. Harry Gregersen.

Valuable information and other assistance came from my father, John Fleming; my uncle Stephen Fleming; my uncle Gerard K. Fleming; Sandy Olsen; Cathy Ball; Jim McNamara; Tom Honkanen; the late Richard Sturm; Marie Haussler Sturm; the late Andrew Havrisko; and the late Marion Deutzman.

In addition, I relied on the work of Louise Hall, former director of the Smithtown Historical Society; former Smithtown town historian Brad Harris; and Barbara Van Liew, the late historian for the village of Head-of-the-Harbor.

Unfortunately, no book is without errors. Anyone who would like to share corrections, images, or information on St. James, Nissequogue, or Head-of-the-Harbor is invited to write to me at 40 Sunny Road, St. James, NY 11780.

—Geoffrey K. Fleming

INTRODUCTION

My earliest memories of St. James are of riding in the backseat of my dad's car, a sky-blue 1968 Volkswagen Beetle; smelling the naugehyde upholstery; and blinking as the sun caught the chrome trim. We also had a Datsun 210 station wagon, but the Bug was the car we traveled around town in. I remember in great detail the buildings we passed on the way to King Kullen or the post office. Coming down Lake Avenue from Sunny Road, we passed the former Little League fields, with the old cages falling apart. Then, on the left just beyond the intersection were Doctor Fischler's office (later, Pat's Place) and two lovely Victorian cottages (demolished for the addition to Pat's Place), and on the right, Sunrise Federal Savings Bank (later Reliance and now North Fork Bank). Lake Avenue still had a lot of empty lots then; it took another 30 years for them to fill up.

So what is St. James? The modern answer is that it is a small hamlet in Smithtown Township, surrounded by a number of incorporated villages. But that was not always the case. The St. James I think of is the "Greater St. James" that includes Head-of-the-Harbor and Nissequogue, the two incorporated villages to our north. Until the 1920s, they were an integral part of St. James, and even after their foundings, everyone who lived there considered themselves residents of St. James. One only has to look at graves in the local cemeteries to see where their hearts were: the inscriptions read "died at St. James," "resident of St. James," and so on.

Although Smithtown was founded by the Smith family in 1665, the area that included St. James was often referred to as Sherrawog, meaning "a place between," or as Head-of-the-Harbor, because of its proximity to St. James (Stony Brook) Harbor. The area located immediately around the Smith homestead was referred to Nissequogue, from the Native American term meaning "the clay, or muddy, country." The name was first noted on maps by the Dutch as Nisunqueeghacky, describing a Native American settlement in the area.

The real name dates from the time of the construction of the St. James Protestant Episcopal Church of Smithtown, or the St. James Episcopal Church. Founded in 1852, the church held its first service in June 1853. There is great debate over how the church received its name. James Clinch, who gathered 59 community residents to create the new church, was certainly the founder. But St. James, better known as St. James the Greater, was at the time believed to be a relation of Jesus Christ, making his name an excellent candidate for the naming of a church.

In 1857, a post office was opened at the recently completed general store on Moriches Road. The store became the center of the community—the place to get mail, supplies, and a bit of local gossip.

Most of the land close to the water was controlled by members of the Smith family and their descendants, who included William Wickham Mills (1797–1865). Mills built a lavish home, designed by Calvin Pollard, along the south side of North Country Road and expanded his land holdings to create one of the largest estates in the area by the time of his death. The farming hamlet of Mills Pond, centered on Mills's estate, was eventually absorbed into St. James.

The Long Island Railroad arrived in St. James in 1873. The track ran south of North Country Road and eventually connected the thriving shipbuilding community of Port Jefferson to New

York City. With the railroad came real estate firms, land speculators, and the development of the wooded area south of North Country Road. The post office moved south to a building a few hundred feet from the general store.

Not only reasonably priced homes but also expensive estates were developed. The train allowed even the most "respectable" person to have a home as far away from the city as St. James. And come they did. Millionaire fur merchant John Ruszits (1816–1890) of New York City had a home in St. James, as did Chubb Insurance founder Thomas Caldecott Chubb (1835–1887). Both men died at their homes in St. James and are buried in the St. James Episcopal Church Cemetery. Famed architect Stanford White (1853–1906) of McKim, Meade, and White arrived and married Smith heiress Bessie Springs Smith (1862–1953) in 1884 and began work on their new home, Box Hill, soon afterward.

At the same time, another group also discovered St. James: vaudeville stars. Vaudeville, which came into being in the early 1870s, was named for Sargent's Great Vaudeville Company of Louisville, Kentucky. The large numbers of performers who vacationed or lived in St. James seem to have arrived due to the influence of William "Willie" Collier (1864–1944). Collier was the son of tragedian actor Edward Collier and nephew of actor Edmund Collier. Willie was one of the leading actors and comedians of his day, starring in many shows on Broadway. It is said he arrived one day with friends on bicycles to St. James and was so taken with the place that he decided that he should have a summer home here. Others soon followed. Famous actor (and brother-in-law) Thomas Garrick (1863–1923) converted a barn on Northern Boulevard into a summerhouse for him and his wife, Helena Collier Garrick (1867–1954). Joseph (1855–1933) and Catherine Tanaka (1863–1946) also joined their Broadway friends here.

For those who could not afford a house, the Shore Inn on Harbor Road was the spot for parties, gambling, swimming, and plain old fun. Retired vaudevillians Anthony Farrell (1856–1926) and Sophie T. Farrell (1860–1938) built their new hotel on property purchased from O. F. Smith around 1897–1900. The inn not only boasted spring water but also operated the St. James Casino, which was only open to guests and their friends. The dock and shore at Farrell's was often crowded with swimmers and pleasure craft and was also the site of the original Bohemian Club (actor's club) building. Other hotels also began emerging elsewhere in St. James. At the intersection of Moriches Road and North Country Road, Gould's Hotel was already well established, and near the train station, the Nissequogue Hotel was opened.

With time the local residents moved south away from North Country Road, as many new developments opened up. St. James Heights was bordered by North Country Road, St. James Avenue (Northern Boulevard), and the Long Island Rail Road tracks; St. James Park was bordered by Lake Avenue, Railroad Avenue, Moriches Road, and Woodlawn Avenue; Agricultural City was bordered by Rutherford Avenue, Claremont Avenue, Woodlawn Avenue, and Northern Boulevard; and St. James Manor was bordered by Lake Avenue, Woodlawn Avenue, Hobson Avenue, and Jericho Turnpike. The largest of these, St. James Park, was developed by the House and Home Company. Noted Northport real estate magnet William B. Codling occupied the Cement Store on Lake Avenue and was a prominent promoter (and sometimes owner) of all the homes for sale in St. James during the first decades of the 20th century.

By 1913, St. James had grown to more than 400 full-time families. The area south of North Country Road was booming and quickly was given the nickname "Boomertown," along with the not-so-pleasing name of "Splinter Village." It must be remembered that until that time, the area had been heavily wooded and was so throughout the first quarter of the 20th century. As everyone else moved south, so did the post office: in 1913, it moved from the small building on Moriches Road to the south side of the of Percy Land's Store near the railroad station.

By this time, the estates in St. James were becoming the primary employers of the community. Censuses indicate that the majority of residents in St. James (including Nissequogue and Head-of-the-Harbor) were employed either as laborers on the farms of the estates or as servants, cooks, maids, laborers, and chauffeurs. Most of the estates were the creations of some of the most prominent members of New York City society who married into the Smith family and therefore

acquired lands. Noted golf course designer Devereux Emmet (1861–1934) married Ella Batavia Smith Emmet (1858–1943); noted attorney Prescott Hall Butler (1848–1901) married Cornelia Stewart Smith (1846–1915); and the rector of St. Ambrose Chapel Rev. Joseph Bloomfield Wetherill (1835–1886) married Kate Annette Smith (1852–1908). Other estate employers were new blood: Louise Archer Thornton (1841–1916) was from Montana, where her Confederate colonel husband made his fortune in mining; John Lewis Childs (1856–1921), the founder of Floral Park, Long Island, was another large employer in his floral business on Mills Pond Road named Flowerfield.

Although outsiders were tolerated when well-to-do, this was not always the case with the average person. St. James had its share of intolerance. As early as 1902, an article in a prominent New York City newspaper cried out for residents of St. James to get rid of immigrants who had started to move into the community. The Howard Orphan Asylum for Colored Children, which later moved to Kings Park, mysteriously burned to the ground in March 1911 (the exact cause was never discovered). St. James also found itself to be a haven for supporters of the Ku Klux Klan during the first decades of the 20th century (a fascinating group of photographs held by the Smithtown Historical Society documents a Klan funeral marching down North Country Road to the St. James Episcopal Church Cemetery during the 1920s).

But nothing could stop the expansion. By the 1920s, many different groups, including those from Norway, Sweden, and Denmark, were arriving here. In 1923, the Sons of Norway Lodge No. 252 was organized in St. James and met at the old Mechanics Hall on Highland Avenue. By 1930, the group had built its own lodge in town. The post office moved south again, to a new building just north of the present Spage's Pharmacy. Gaynor Park was opened on Woodlawn Avenue to honor Mayor William Gaynor (1849–1913), late owner of Deepwells, and on the opposite side of the street along Tredwell Avenue were the practice fields for the fire department.

The late 1920s also led to the division of the community into separate entities. Residents in the northern part of St. James, wanting to protect their neighborhoods from the kind of development that they had watched occur to the south, created the incorporated villages of Nissequogue and Head-of-the-Harbor. Although this division was real, in many ways it was not. Both villages did (and still do) rely on St. James for nearly all of their services, including their mail. At the same time this division was occurring, St. James was seeing a change in its population. The actors were beginning to leave, either due to death, the collapse of vaudeville, or the lure of the movie industry in California. And many estate owners began splitting up their property for development and for badly needed money (Ella B. Emmett sold the Smith Estate Sherrewogue in 1934 after 236 years of continuous ownership).

The hotels also began to disappear. Gould's became a restaurant, and Peter Myers's (1866–1912) St. James Park Hotel, on Lake Avenue and 3rd Street, disappeared altogether. World War II and its aftermath helped transform St. James from a small farming community into one that included more and more people who worked in the city (my own family arrived here in 1951 while my grandfather continued to work in New York City as a police officer). After the war, Childs's Flowerfield became home to the Gyrodyne Company of America, engaged in the design, testing, development, and production of helicopters for the U.S. Navy.

New developments continued to sprout up, especially out of the old estates, which broke up at a rapid pace as inheritance and property taxes soared. Harbour Close I, II, and III were formed out of the Thornton and Oxnard estates, Pond Woods and Harbor Point were developed from the estate of Christopher Temple Emmet (1868–1957), and the estate of Alice Throckmorton McLean (1886–1968) became the Harbor Country Day School in 1958. The expansive Georgian-style estate of Hon. Lathrop Brown (1883–1959), a former congressman and assistant secretary of the interior, became home to the Knox School in 1954. The new Smithtown High School also opened in St. James around 1960, bringing with it the end of the local board of education.

As the number of full-time residents began to rise, the post office moved again (1963), this time to its present location between Lake Avenue between 5th and 6th Streets. About the same time, home delivery of the mail began. Since most homes in St. James did not have house numbers, the mailman walked around town assigning numbers. My grandparents were not home when

the mailman came down Grant Avenue. My father and his siblings were, however, and when the mailman asked them, "What number do you want your house to be?" they replied they did not know. "Well," the mailman said, "the house next door is 241. How about 243?" That was how the house became 243 Grant Avenue.

By the time I was born and being raised in St. James, things were changing fast. The O'Berry-Hartmann farm (technically in Brookhaven, but always associated with St. James) was becoming the Fairfield Condominium Retirement Community. Other large farms nearby were also being developed. Unfortunately, along with increased development usually comes historical loss. Many early homes and buildings that might have been preserved were demolished. The Smithtown Club, established by Paul Martinette of show business fame and later becoming the Smithtown Outing and Beach Club and then Prince Farms, was developed for housing beginning in the early 1990s. The magnificent early-18th-century home owned by noted New York City architect Leon Barton (1906–1989), located just west of O'Berry's Garage, was also lost, and to this day nothing has been built on the site.

Part of my reason for putting this book together is to encourage those who live here today and those who will follow us tomorrow to preserve what we have left and to maintain all those aspects that make St. James so special.

—Geoffrey K. Fleming
April 2006

One

PUBLIC INSTITUTIONS

Each community, no matter where it is located, has those centers that become the foundations of their settlement. For St. James, it took the erection of a new church in the 1850s to give focus and a name to the area. From that moment forward, nearly every successive community organization began to appear. Some still exist; others have long since disappeared. One such organization was the St. James dental clinic that aided those who needed help when it came to their teeth. The two local halls provided meeting places for community activities and gossip. Others were fraternal in nature, creating places for people to meet and share the camaraderie that they may not have found elsewhere. Protection of life and property (along with a few large fires) helped spur the creation of the fire department. The need for self-improvement and greater access to education led to the creation of the now defunct St. James Board of Education. Entertainment and commerce led to the formation of still others. All of these organizations became the lifeblood of the community during various periods of the community's history. They supported and nurtured St. James, helping to bring it into the modern era.

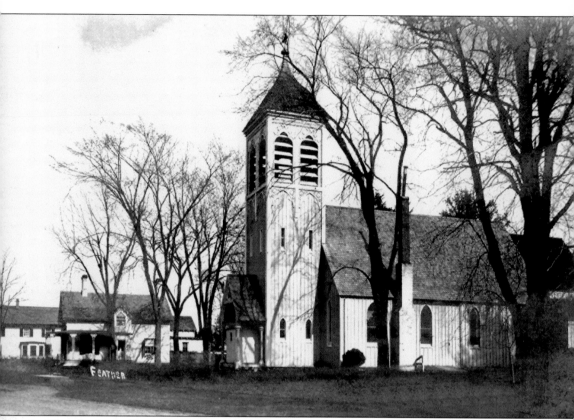

THE ST. JAMES EPISCOPAL CHURCH OF SMITHTOWN, C. 1890. Founded in 1852, the church was constructed in 1854, and it is this building that helped give the community its name. Designed in the Gothic style by noted American architect Richard Upjohn (1802–1878), the building was erected on land donated by Joel L. G. Smith, builder of Deepwells. It is said the church was named for James Clinch, who was one of the primary organizers of the new parish. The large bell tower was added in 1877 through funds donated by noted merchant and businessman Alexander T. Stewart (1803–1876). The Episcopal church became the second home for most of the estate owners who resided in St. James during the summer. Today one can find many of their graves in the cemetery, including that of famous architect Stanford White (1853–1906).

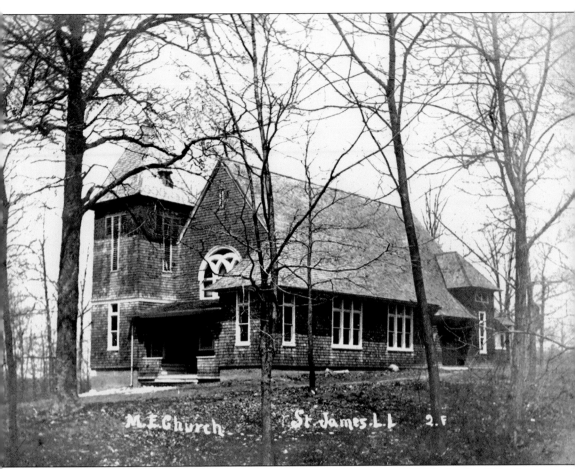

THE METHODIST CHURCH, C. 1900. Know locally as the Thompson Hill Methodist Church, it is the second building on the site. The Methodists organized in 1869 and acquired the land on which the church was constructed from Gideon and Sarah Smith in 1870. The first church, constructed in 1872–1873, was destroyed by fire on October 13, 1897. The new building, erected in 1898, continues to this day to be the home of the Methodist church. A Sunday school facility and meeting hall was added in 1961, followed by a further addition to the school in 1969.

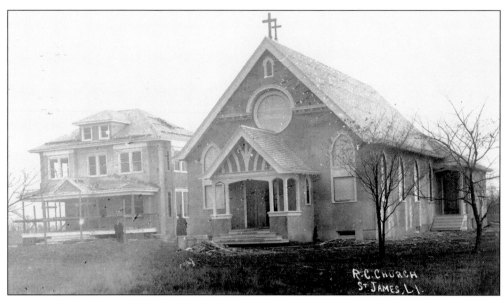

STS. PHILIP AND JAMES ROMAN CATHOLIC CHURCH, C. 1908. Shown under construction, the first Catholic church was dedicated by the bishop of Brooklyn Charles E. McDonnell (1854–1921) and first shepherded by Fr. William J. Duhigg (1878–1929). Founded as Sts. Thomas and James, everyone soon realized that Philip, not Thomas, was actually James's cohort, and the church was renamed. The complex included a rectory and later, a convent. Completed in 1922, the convent was first home to the Sisters of the Holy Name and in 1939 became home to the Sisters of the Holy Union. A new church and school were constructed south of the old site in 1962, and when the old church was deconsecrated, several residents who had been buried around the old building were disinterred and removed to St. Patrick's Cemetery in Hauppauge. The old rectory, convent, and parish house were demolished for a new rectory and residence in 1995. The original old church continues to be used for meetings and youth programs.

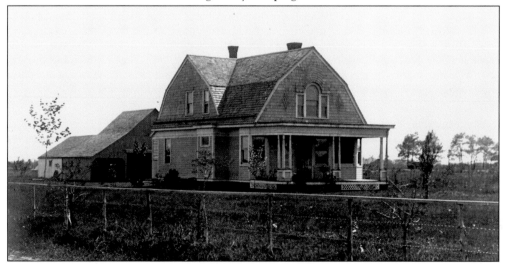

FATHER DUHIGG'S HOUSE, C. 1910. Father Duhigg was the first priest of Sts. Philip and James Parish. He was well respected within the congregation and saw the church through its infancy from its beginning in 1907 until his death in 1929. His house, located across the street from the original church on North Country Road, remains a private residence today.

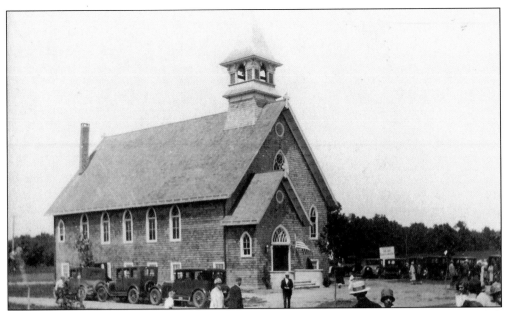

ST. JAMES LUTHERAN CHURCH, C. 1930. Since 1905, there had been efforts afoot to establish a Lutheran church in St. James. The present church, shown here, was constructed in 1928. It served the needs of the huge northern European populations, including immigrants from Norway, Sweden, and Germany, who flocked to St. James during the early 20th century. Originally constructed with a very informal entrance porch, a large, classically designed portico was added to the church in 1963. For decades, the church has been home to the well-known St. James Lutheran Nursery School.

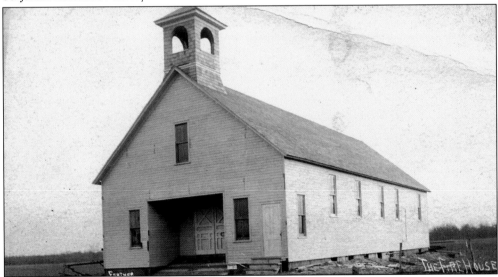

THE EAGLE HOOK AND LADDER COMPANY, C. 1913. The first fire protection company for St. James was constructed on the south side of Woodlawn Avenue near the present Lutheran church. Its cornerstone was laid on July 2, 1910, with Mayor William J. Gaynor and Congressman W. W. Cocks presiding. Though dedicated in 1910, it was not until 1913 that the building was completed. A wooden structure, it was quite alone on the road when it was first erected. It still stands today as the Full Gospel Assembly of God Church on Woodlawn Avenue.

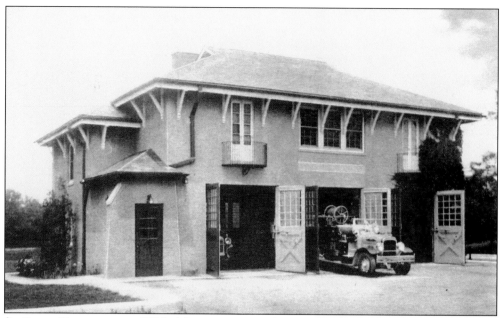

ST. JAMES FIREHOUSE, C. 1925. After many years of service, Eagle Hook and Ladder Company became insufficient for the needs of St. James residents. A disastrous fire on January 1, 1922, led to the expansion of the fire department. A new, fireproof building was designed by local architect Lawrence S. Butler and erected on the other side of town on North Country Road near O'Berry's (later Penney's) Garage. The firehouse was enlarged several times after its initial construction, including an addition in 1939 and enlargement in 1950 (which was designed by Leon Barton, another local architect), but the style, with its large decorative brackets, remained the same.

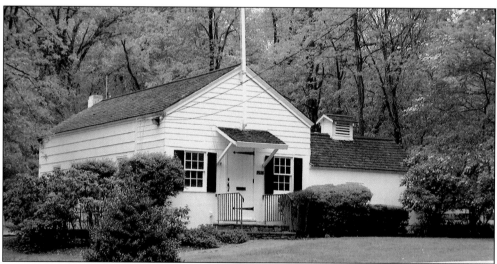

THE NISSEQUOGUE SCHOOL. None of the earliest schools (those organized in the 18th century) survive in St. James today. The earliest still standing is the Nissequogue School, which was organized in 1808. The present building served as the local school for many decades. When the Village of Nissequogue was founded in the 1920s, it needed a home. The school, no longer in use, was acquired to become the village hall.

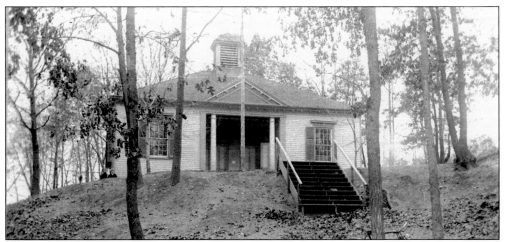

ST. JAMES SCHOOL, C. 1900. The school, located on Three Sisters Road, has always been identified with Stanford White, who has been suggested as its designer. The school replaced one of the earlier district schools that were common across Long Island during the 19th century. Opened in the late 1880s (the earlier school was moved across the street), it was closed after the construction of the new school on North Country Road in 1905. It was then sold to Louise Thornton, who later sold it to her friends and neighbors the Minott family. Today it still stands (and is still a private residence) as a reminder of the educational history of the area.

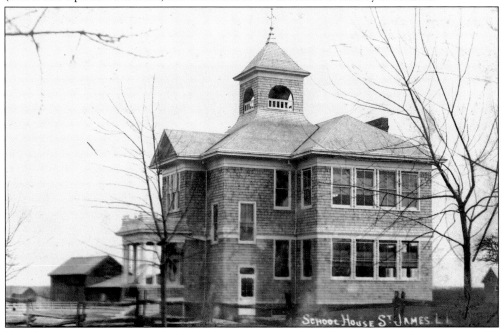

THE ST. JAMES PUBLIC SCHOOL, C. 1908. This large shingle-style school was erected along North Country Road, opposite Penny's Garage in 1905 to replace the much smaller school that had been erected on Three Sisters Road. Designed by architect William Sidney Jones and built by Herbert F. Smith, its large bell tower made it possible to hear the school bell throughout St. James. Abandoned after the completion of the new St. James Elementary School in 1938–1939, it was divided up into apartments for decades. It was purchased in 1993 by local resident Pat Mazzeo and restored to its former glory.

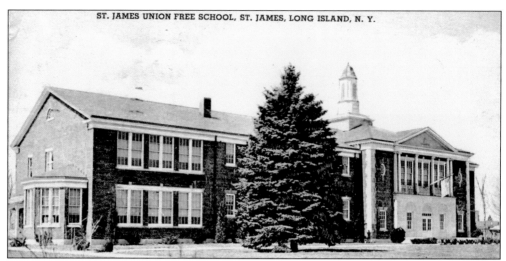

ST. JAMES UNION FREE SCHOOL, ST. JAMES, LONG ISLAND, N. Y.

ST. JAMES ELEMENTARY SCHOOL, C. 1940. The final school built by the now defunct St. James Board of Education was constructed in 1938–1939 on the west side of Lake Avenue. It was designed by Amityville architect Lewis Inglee (1885–1960) and built by Leslie R. Marchant. This grand, classically designed building replaced the equally grand home built by Father Ducey, whose estate had been a fixture on the avenue for many decades. The main building remains largely unchanged today, although it has been greatly enlarged since the 1930s.

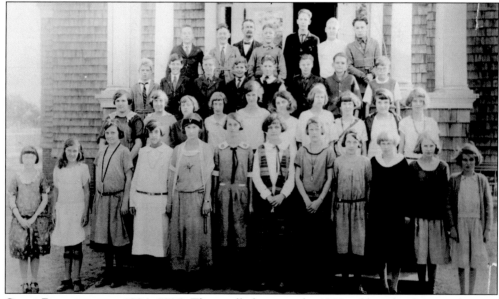

CLASS PHOTOGRAPH, 1924–1925. The small classes at the 1908 public school are made more evident by this photograph. From left to right are (first row) Vivian Smith, Isabel Lawrence, Marie Haussler, Ida Phillips, Margaret Balazs, Helen Overton, Borghild Hammer, Wilhelmina Haas, Irene Haussler, Alice Maybe, Merthel Nichols, and Gladys Marshall; (second row) Helen Gould, Elizabeth Draper, Pauline Mallet, Tessie Immel, Evelyn Lawrence, Anna Jirik, Elizabeth Oman, Cecelia Ellis, Dorothy Reichling, and Bertha Bryant; (third row) Edward Schoyen, John Lawrence, George Kerr, Arthur Bowe, Ralph Lowe, Albert Danielson, Boris Radoyevich, and Henry Simkatis; (fourth row) Radar Anderson, Terry Burr, Carl Hammer, Maurice Olsen, Harold Sidenius, and Royal Ott. The teacher and principal (back) is William Schoonmaker.

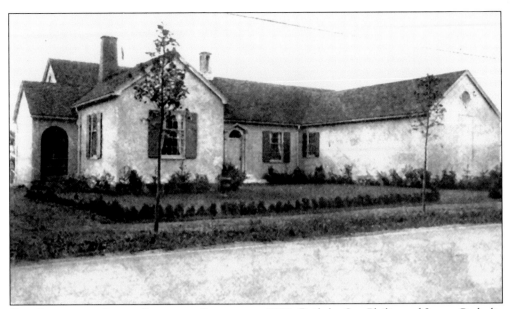

STS. PHILIP AND JAMES CATHOLIC SCHOOL, C. 1925. Built by Sts. Philip and James Catholic Church in 1922, the school grew decade after decade until it was replaced with a new building in the 1960s, located just south of this structure attached to the new church. Today the building is still used for educational purposes by the parish.

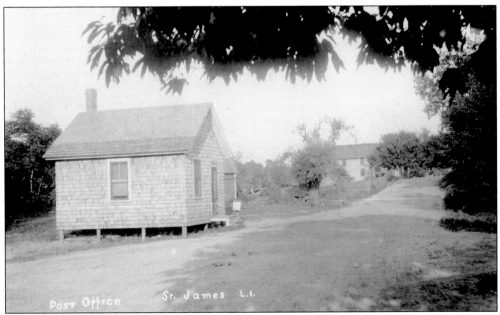

THE SECOND POST OFFICE, C. 1905. The post office had been located in the St. James General Store for many years prior to moving to this new building, just a few hundred yards away from the store. It remained here until it moved up on to Lake Avenue in 1913. In the background, the blacksmith shop of William Monahan can be seen.

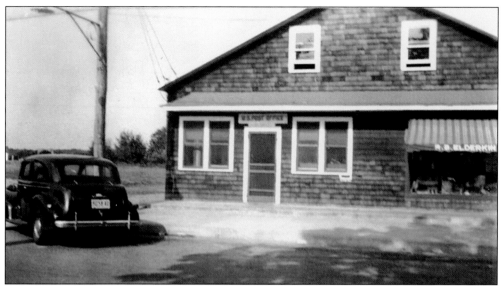

THE POST OFFICE, C. 1940. Nowhere in any of the literature is the post office mentioned as being in this building, which sits opposite the present-day elementary school and just north of the Percy Land Store. Yet, here it is—sitting next door to R. B. Elderkin's store.

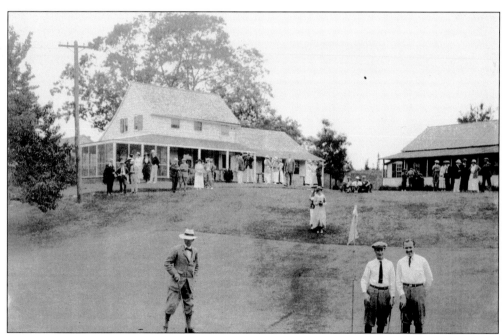

THE CLUB, C. 1925. This scene was shot at the Smithtown Club, which was opened along Edgewood Avenue and Fifty Acre Road in 1924 and which became home to the Smithtown Hunt and Polo Club. During the successive decades, the club was reorganized as the Smithtown Outing and Beach Club. By the 1990s, it had been acquired by neighboring Prince Farms. It was sold for development not too many years later.

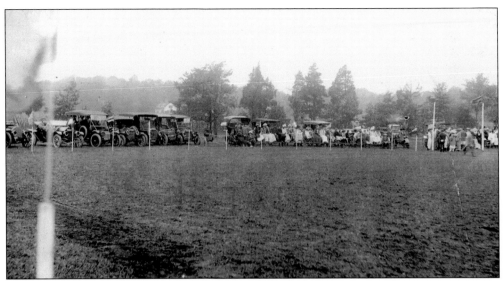

AT FIFTY ACRE FIELD, C. 1918. A multitude of fashionable automobiles line the edge of the polo field at Fifty Acre Field. This site, along with the Smithtown Club, became the major location for many of the great social and sporting events that took place in St. James for nearly 50 years.

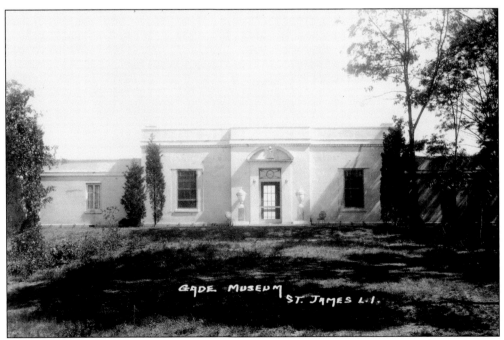

THE GADE MUSEUM. The Gade Museum was completed in 1926 for Capt. John Allyne Gade (1875–1955) as part of his estate Ekholm. A noted architect and collector of antiques, Gade had this structure built to house his many collections. Sources indicate that William A. Delano (1874–1960) designed the building and William Huntington made later additions. After Gade's death, the facility was supposedly left to the community as a museum for their benefit, but no one seems to know what happened to it.

SONS OF NORWAY LODGE (LOYAL LODGE NO. 252), 1930. Since the beginning of the 20th century, St. James has boasted a large Norwegian population. The Sons of Norway Lodge was first organized in 1924, and the building that became their home was constructed in 1930 on the corner of Seventh Street and Fourth Avenue (St. James Park) as a place to gather and honor their Norwegian ancestry. The hall is shown here under construction. It is still their meeting place and can be rented for parties and special events.

Two

ESTATES

Although there were a few houses built during the mid-19th century that today would be called estates (Rassapeague, Mills Pond House), they would pale in comparison to what was to come. By the late 19th century, carefully designed mansions and professionally organized landscapes began appearing in St. James. At first, most were adaptations of earlier houses, such as Box Hill, but many newly designed estates soon appeared. It was no coincidence that many were built by individuals who had married into the Smith family and their many related families. After all, to build a house one needs to have a plot of land on which to place it. Prescott Hall Butler, Stanford White, Devereux Emmett, and James W. Phyfe all married Smiths (Phyfe went through two Smith sisters during his life). Architect Lawrence S. Butler renovated and redesigned the noted building "Timothy House" into a lovely estate that was long rented to Frederick Minott. Women, both native and new, played an important role in the development of many of the estates. Louise Thornton, Ella B. Emmett, and Alice McLean all had a hand in creating these luxurious places of respite. By 1920, St. James was "bursting at the seams" with estates that ranged in size from a few acres to more than 600.

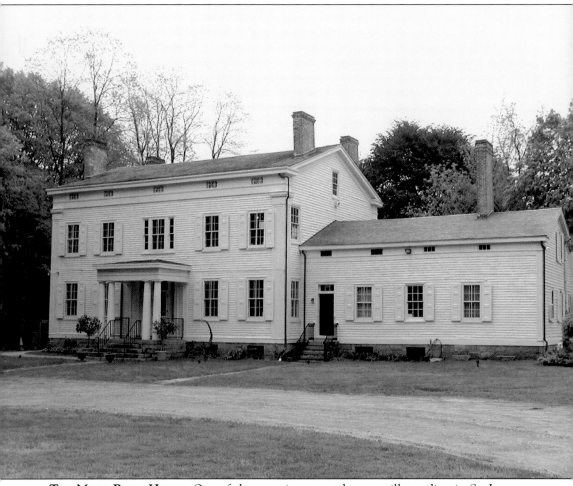

THE MILLS POND HOUSE. One of the most important houses still standing in St. James was constructed in the area that was known as Mills Pond Village in the mid-19th century. Designed by noted New York City architect Calvin Pollard (1797–1850), the house was built for William Wickham Mills (1796–1865), one of the wealthiest men in Suffolk County. The magnificent Greek Revival mansion was the seat of the Mills family and their descendants until 1976, when the home was donated to the Town of Smithtown to be preserved for future generations. Mildred and Josephine Smith, two of the last occupants of the house, are remembered as the local Girl Scout troop leader and the local Sunday school teacher. The house has been the home of the Smithtown Township Arts Council since that time. The once grand barn that stood next to the house (but was not owned by the town) collapsed a few years ago.

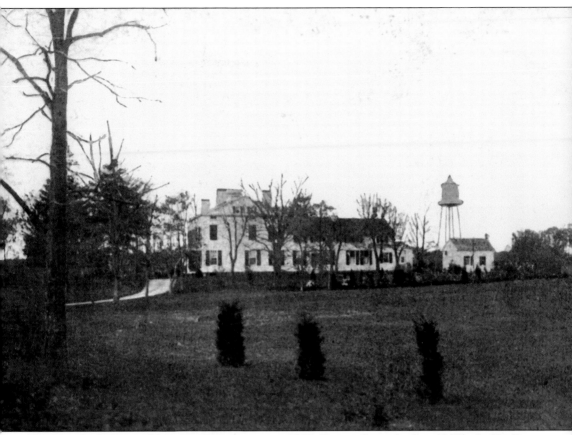

THE JOEL L. G. SMITH MANSION, DEEPWELLS, C. 1905. Deepwells was built in 1845 by Joel L. G. Smith (1819–1876), a descendant of town founder Richard "Bull" Smith and a founder of the Episcopal church. The lavish, Greek Revival mansion was the centerpiece of Smith's large farm. The house was sold after the Civil War to Milton H. Smith of New York and was later occupied by his son, Clinton G. Smith (no relation to the local Smiths). But the home is most associated with Mayor William J. Gaynor of New York City. The estate was Gaynor's summer retreat until his death in 1913. The property was subsequently acquired by Winthrop Taylor (1884–1975), who occupied it until he died. It then fell into disrepair during the ownership of Taylor's son, Jeremy, and was nearly demolished for development before Suffolk County purchased, restored, and opened it to the public in 1995.

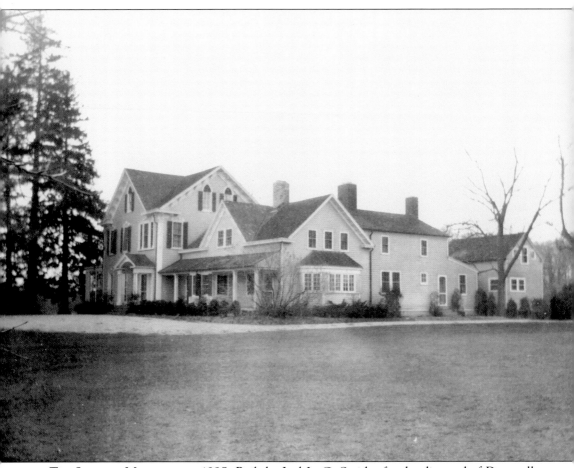

THE LAWSON MANSION, C. 1895. Built by Joel L. G. Smith after he disposed of Deepwells, this house is most often referred to as the Lawson House, named for its later owners Stanley (1864–1919) and Helen Smith Lawson (1863–1944), Joel's daughter. Located along the bend on North Country Road near Gate Road, the very elegant Victorian house included land and farm buildings across North Country Road as well. The Lawsons' neighbor Alice Throckmorton McLean acquired the property and added it to her own estate. Today the main house is still privately owned.

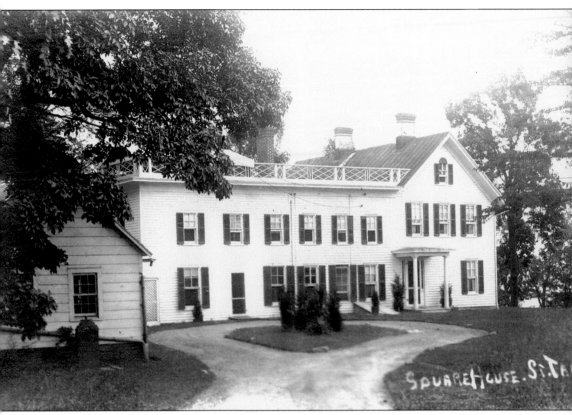

THE THOMAS S. SEABURY MANSION, RASSAPEAGUE, C. 1917. This mansion was built around 1865 for Thomas S. Seabury, nephew of artists William Sidney (1807–1868) and Shepard Alonzo Mount (1804–1868). Seabury planted the first grape vines here and earned recognition for having "the most complete collection of choice wine grapes in New York State." In 1879, John Ruszits (1816–1890) bought the estate, improved the vineyard, and established a winery, known for its Rassapeague claret. Ruszits, one of the leading furriers in the United States, became St. James's first millionaire resident (excluding the Stewart heirs). Having arrived from Hungary in 1844, he ran his business from the Ruszits Building, erected in 1875 at 73–77 Mercer Street, New York City. Following his death, his widow, Clara, married Welcome G. Hitchcock (1833–1909), who took over Ruszits's business and was a partner in W. G. Hitchcock and Company, importers. After Clara's death in 1915, Francis Cleveland Huntington (1865–1916) bought the estate and hired local architect Lawrence S. Butler (1876–1954) to add a service wing and reorient the house toward the water. Later renamed Square House, the estate was used briefly as a private boys' school (advertised as providing "Training for Christian Manliness"). It remains a private residence today.

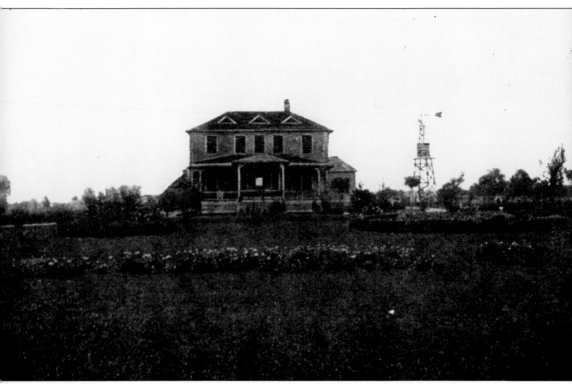

FATHER DUCEY'S HOUSE, C. 1910. The Reverend Monsignor Thomas J. Ducey (1846–1909) was the first pastor of St. Leo's Church and Parish, at 28th Street near Madison Avenue. Ducey, a founder of the parish in 1880, lived at 16 East 29th Street, New York City, and summered at his St. James estate on Lake Avenue on the site of the present St. James Elementary School. His property included 15 acres and a $25,000 house. Following Ducey's death, the estate was left to St. Leo's, which sold the house to benefit the parish. Margaret Brennan was the next occupant, followed by the Peterson and Broderick families. After being damaged by fire, the house was sold and demolished for the new St. James Elementary School in 1938–1939.

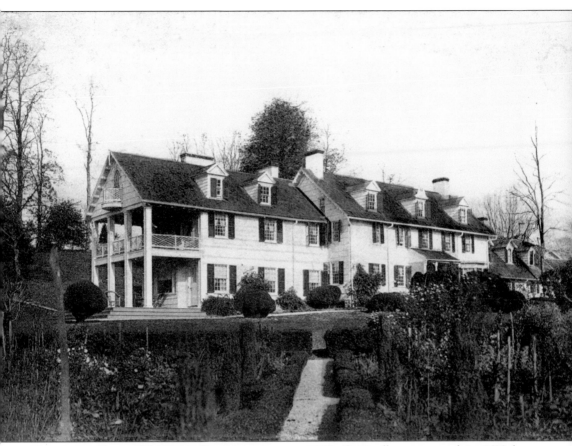

THE ADAM SMITH MANSION, SHERREWOGUE, C. 1910. Originally constructed in 1698 by Adam Smith, a descendant of Richard "Bull" Smith, the home was enlarged several times during its history. A large shingled residence, it was the home of Devereux and Ella Batavia Smith Emmett, who commissioned architect Stanford White (1853–1906) to add a large wing on the west side. Ella Emmett owned over 600 acres in St. James, including nearly half of the village of Head-of-the-Harbor. She was the last Smith descendant to own the house. In 1934, Frederick McNeal Bacon III (1899–1982, no relation to George Bacon), a creator of contract bridge, bought the property. His wife was the noted photographer Toni Frissell (1907–1988). Sherrewogue remains one of the most elegant estates, with many outbuildings and a well-preserved main residence.

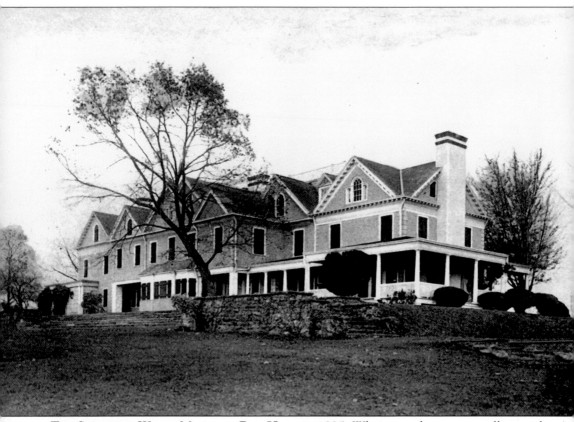

THE STANFORD WHITE MANSION, BOX HILL, C. 1895. What started out as a small, typical Long Island farmhouse became, in the hands of one of America's most important Gilded Age architects, a glamorous and elegant showplace. Stanford White (1853–1906), a partner in the prominent architectural firm McKim, Mead, and White, married Bessie Smith (1862–1953), a descendant of Richard "Bull" Smith. In 1892, White acquired Samuel Carman's 1850s farmhouse and transformed it into a country retreat. Box Hill remained in the family after White was murdered in 1906 by Harry K. Thaw, the jealous millionaire husband of actress Evelyn Nesbit. Son Lawrence Grant White (1887–1956), also a respected architect, was among the family members who have lived there.

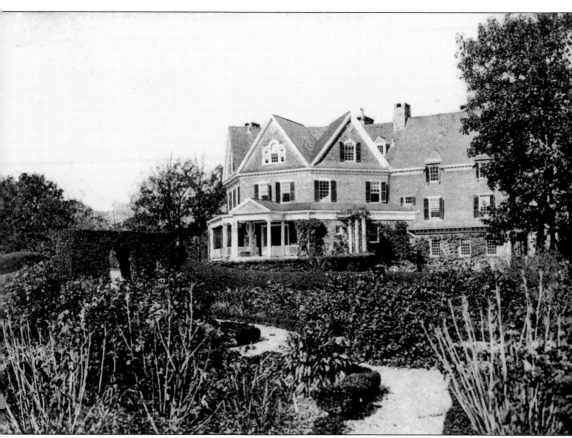

THE WIDOW WETHERILL MANSION, WETHERILL COTTAGE, C. 1900. Stanford White's sister-in-law, the widow of the well-respected Rev. J. Bloomfield Wetherill (1835–1886), commissioned White to build her a summer residence next door to Box Hill in 1893. Completed in 1895, hers was one of the first great planned estates built in St James. Its octagonal shape made it stand out among the many Colonial and early-19th-century homes in the area. Throughout most of the 20th century, it was home to Barrent (1882–1955) and Isabella Macoomb Wetherill Lefferts (1883–1964) and their daughter, Kate (1911–2000). The house was the scene of a brazen robbery in the early 1950s. Today the house and some outbuildings remain, but much of the property has been developed.

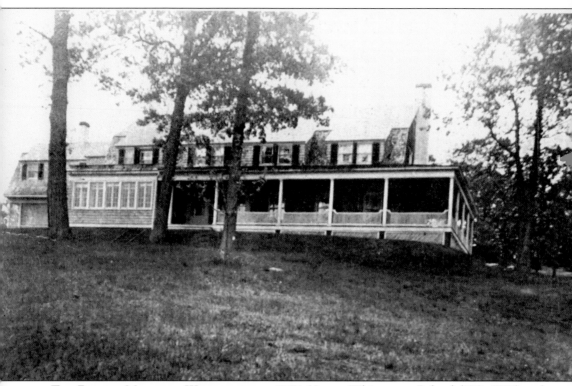

THE REBOUL MANSION, WOODCREST, C. 1917. Homer Whittemore Reboul (1851–1927) and his wife, Garetta Hagemeyer Reboul (1869–1947), were the in-laws of Joel Smith Lawson, who was born in 1892 to Stanley and Helen Smith Lawson. They built a summer home in St. James around 1895 and acquired a 100-acre estate in Nissequogue on the east side of Moriches Road. The Reboul mansion was designed in the shingle style by Sayville architect Isaac Henry Green (1858–1937). Homer was from Astoria and operated the fur business begun by his father, John B. Reboul (1812–1894), which was located in Long Island City. Homer served on the board for Astoria Hospital, which opened in 1896. Woodcrest was later renamed Foxfields and passed on to attorney Sigourney Butler Olney (1888–1956) and then to Charles Embree Rockwell (1916–2001). The estate has been heavily developed since 1944.

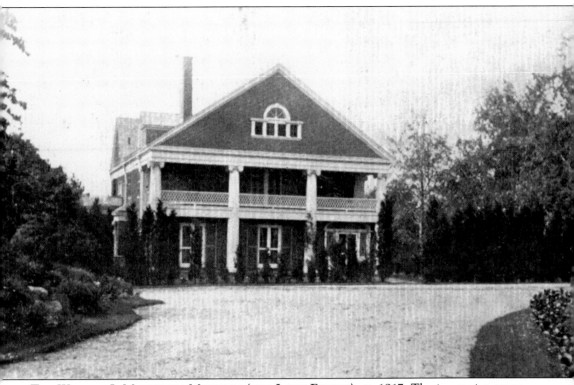

The William J. Matheson Mansion (the Lane Estate), c. 1917. The impressive estate overlooking Short Beach was built for noted chemist and yachtsman Dr. William J. Matheson (1857–1930). An earlier house had been built here, probably for the Newton family. Matheson sold his estate to Albert A. Stewart, who was lost in the sinking of the *Titanic* in 1912. The house was then acquired by James Warren Lane (1864–1927) and his wife, Eva Metcalf Bliss (1875–1922), the daughter of Eliphalet Williams Bliss (1836–1903), founder of the E. W. Bliss Company (manufacturer of torpedoes, dies, and presses). Named Suffolk House, the building was moved in 1912 to avoid the winds, renovated by architect Arthur Little (1852–1925), and decorated by Elsie De Wolfe (1865–1950). The Lanes also owned Robins Island in Southold Town, which served as a hunting preserve (sold in 1927). The Lane estate included a number of Colonial Revival–style outbuildings and cottages and an elegant tennis court and classical pavilion. The tennis court is now gone (around 1995), but the mansion and some cottages and outbuildings still survive. The estate had its own fire hydrant system, which was still in operation as late as 1978.

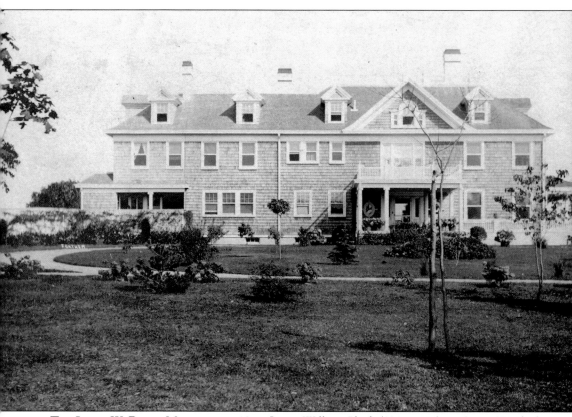

THE JAMES W. PHYFE MANSION, C. 1910. James William Phyfe (1844–1914) ran James W. Phyfe and Company, a New York City coffee and spice importing company, and opened and operated the Monomonock Hotel (built in 1902, demolished in 1940) in Caldwell, New Jersey. He married into the Smith family twice, first to Anna Lawrence Smith (1846–1877) and then Anne Carll Smith (1852–1911). His home, built late in his life, was designed by Isaac Henry Green (because of his impressive work on the neighboring Reboul home) and was completed between 1900 and 1904. After Phyfe died, his son-in-law, Norman H. Parke (1877–1968), ran Camp Nissequogue Harbour on the property from about 1925 to 1927, when the home was sold to New York banker William H. Hamilton. By 1935, it had become the respite of young Gloria Vanderbilt, born in 1924, whose famous family members were fighting for custody of her. The property has since been subdivided, although the mansion and some original outbuildings survive.

THE FRANCIS C. HUNTINGTON MANSION, C. 1920. Built in 1908, the house was one of the very first to employ terra-cotta block construction, first approved for use in New York City in 1907. The house's builder, Francis Cleveland Huntington (1865–1916), was a lawyer with the firm of Huntington, Rhinelander, and Seymour. He was married to Susan Louisa Butler (1879–1958), who after his death remained his widow for over 40 years. The house was not located as close to the water as many of the other estates were. Instead, the home was located on the top of a large hill on the south side of Moriches Road. Susan's son, Charles, owned the neighboring Branglebrink Dairy Farm, which was known for its high-quality milk and homemade ice cream.

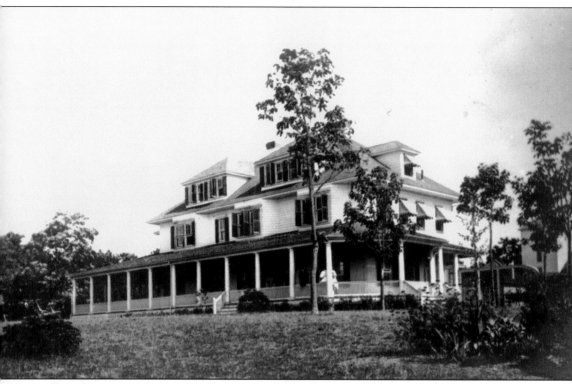

The Oxnard Mansion, Overlook, c. 1910. Sugar beet magnate James Guerreo Oxnard (1861–1919) and wife, Caroline Moss Thornton Oxnard (1875–1953), acquired some of the St. James property of vaudeville actor Jerome Sykes (1867–1903) for their summer home. Located on a hill, with sweeping views of the harbor, the c. 1908 house was enlarged around 1910 to a shingle-style residence, designed by Sayville architect Isaac Henry Green (1858–1947). The Oxnards later sold land to Caroline's mother, Louise A. Thornton, for her estate. Following James Oxnard's death in 1919, Caroline married family friend and mining engineer Arthur Claypoole Carson (1860–1939) and renamed the house Carson Place. Caroline's sisters, Adelaide Corbett (1872–1963) and Lucille Thornton (1874–1949), bought Carson Place in 1921 and joined it with their late mother's estate. The entire property was demolished for the Harbour Close development in 1955–1956.

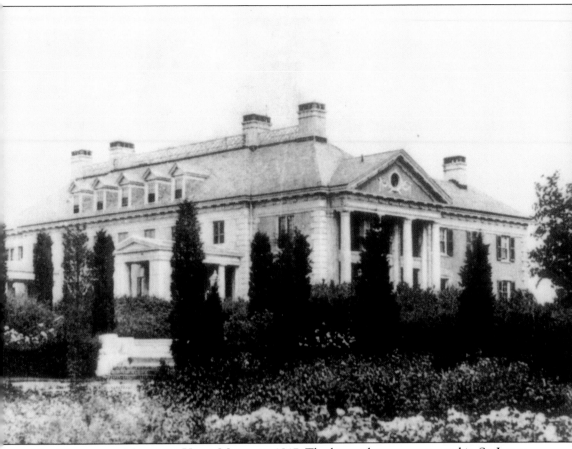

THE THORNTON MANSION, VILLA MEMO, C. 1917. The largest house constructed in St. James during the estate period (around 1880–1930) was built by Louise Clementine Archer Thornton. She was the widow of Confederate colonel and attorney J. C. C. Thornton (1834–1887), whose mining claims made him one of the wealthiest residents of Butte, Montana. After her husband's death, she moved to New York City and followed her daughter and son-in-law (Mr. and Mrs. James Oxnard) to St. James for the summers. Her home, built between 1908 and 1911 and known as Villa Memo (Memo was her grandchildren's nickname for her), had 74 rooms and many outbuildings. Gate Road served as the main driveway into the estate. Many members of the family owned the house during its existence, including William D. Thornton (1870–1953). Local resident Freemont Overton was the longtime head gardener and caretaker of the estate's large greenhouses. The house was demolished by the Center Island Corporation between 1955 and 1956 for the Harbour Close housing development, although several outbuildings and garden creations survive.

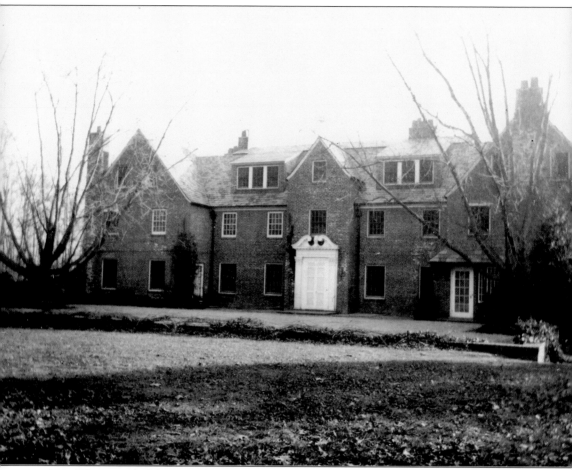

THE WILLIAM A. MINOTT MANSION, C. 1940. The Minott Mansion was built for William A. Minott (1873–1959), an heir of the Goodyear Rubber Manufacturing Company of New Jersey. Financial losses, however, soon forced Minott to sell the recently completed summer home. Phelps-Dodge Corporation president and financier James McLean (1845–1920) and his wife purchased the estate and lived there even after 1917, when they sold it for a small sum to their daughter, Alice Throckmorton McLean. Alice, married until 1915 to Edward Larocque Tinker, founder of the Tinker National Bank (later Marine Midland), renovated the house into a brick-clad English country manor and continued to acquire more and more property in St. James until the 1930s. The estate became the Harbor Country Day School in 1958 and sustained fire damage years later. The house is in good condition today, but many of the outbuildings are either in disrepair or no longer standing.

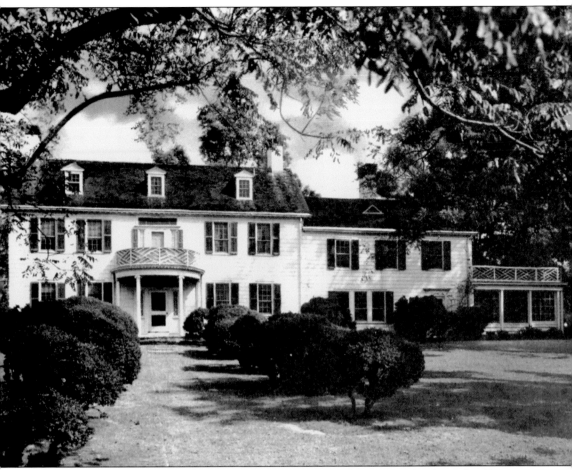

THE BACON MANSION, THATCH MEADOW FARM, C. 1925. Engineer and industrialist George Wood Bacon (1869–1953) acquired Thatch Meadow Farm and created a large country estate and working farm there. Bacon Road became the drive to the house and was closed each season by Bacon, who would hang a "road closed" sign, much to the chagrin of local residents who had used the road in years past. In 1950, Bacon sold the main portion of his property to bank executive Viola Billings (1892–1979), who kept lavishly manicured gardens. Part of the estate has been developed over the years, but Billings's descendants still own the main house and much of its surrounding acreage.

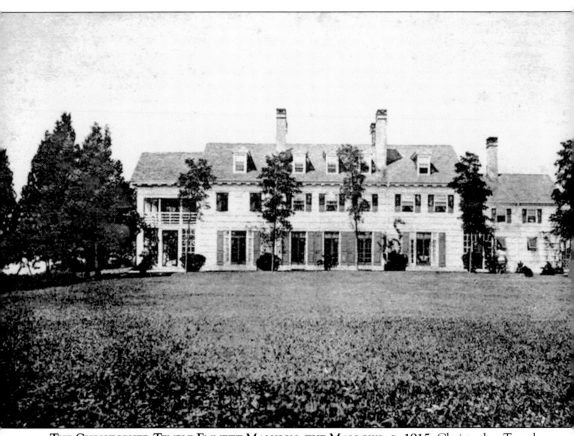

THE CHRISTOPHER TEMPLE EMMETT MANSION, THE MALLOWS, C. 1915. Christopher Temple Emmett (1868–1957), brother of Devereux Emmett, was an attorney with a keen interest in forestry. His wife, Alida Beekman Chanler (1873–1969), was an heir to the William Backhouse Astor (1792–1875) fortune. The Mallows was designed by noted architect Charles Adams Platt (1861–1933), with additions by Stanford White, who designed the barn and the chicken coop, which eventually became the residence of youngest son, Thomas Addis Emmett (1915–1990). The large property has been developed, but the mansion still overlooks St. James (Stony Brook) Harbor.

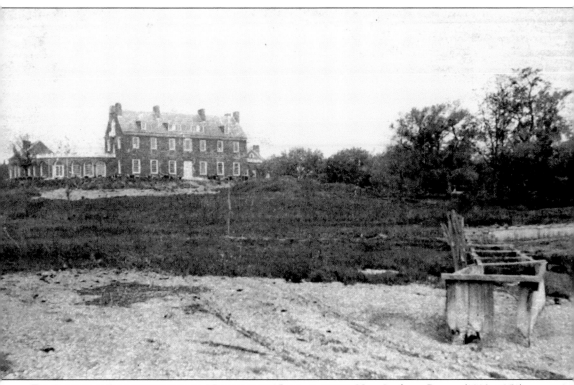

THE LATHROP BROWN MANSION, HOUGHTON HALL, C. 1920. Hon. Lathrop Brown (1883–1959) was a congressman, businessman, and brother of architect Archibald Manning Brown (1881–1956) of Peabody, Wilson, and Brown. The St. James mansion, built between 1915 and 1917 for him and his wife, Helen Hooper Brown, was one of several residences he owned, including one in Montauk. The brick Georgian-style mansion had a circular horse stable, a half-mile racetrack, and a tower. Brown put the property up for sale many times, beginning in 1929. Later owners included the LaRosa family (of pasta fame), and in 1953, the Knox Boarding School of Cooperstown moved here. Recently, the school announced its intention to develop part of the acreage, much to the worry of some local residents and neighbors.

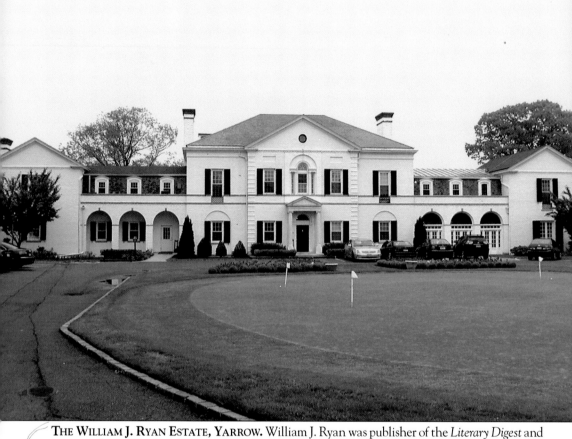

THE WILLIAM J. RYAN ESTATE, YARROW. William J. Ryan was publisher of the *Literary Digest* and vice president of Funk and Wagnalls, the publishing company his father-in-law, Robert J. Cuddihy (1862–1952), led to distinction. Designed in 1929 by Long Island architect John Washington Bradley Delehanty (1888–1965), Ryan's estate was one of the last built in the area. The Ryan family owned the house until the mid-1960s, when it was sold to become the Nissequogue Golf Club. Daughter Ruth Ryan Sanford (1918–1942) famously committed suicide on February 19, 1942, in her nearby home Brookshot, on Harbor Road.

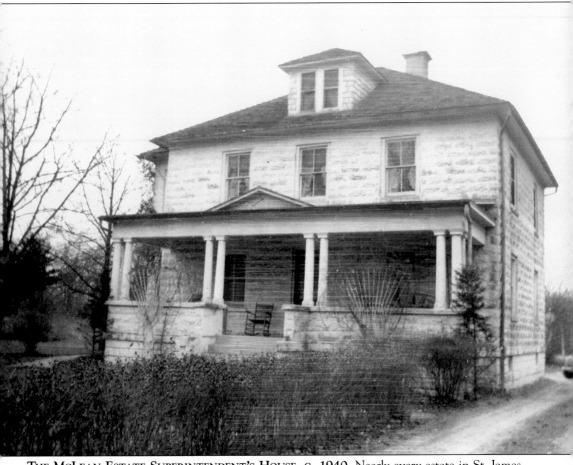

THE McLean ESTATE SUPERINTENDENT'S HOUSE, C. 1940. Nearly every estate in St. James had a cottage or house for its superintendent. Built of concrete block, this house was used years later as part of the St. James School of Horsemanship. In the 1960s, the large stables behind the house burned, and in the early 1990s, the house itself was destroyed by fire. Today Hitherbrook Nursery has expanded onto the property.

GATE ROAD, C. 1925. Gate Road, with its white stones, perfectly spaced tress, and wide expanses of lawn, was the driveway to the Thornton Mansion. Today it is a wooded and overgrown road. This photograph shows how much can change in a community in a time span of just 50 years. It was probably along this drive that W. D. Thornton lost two of the spare tires belonging to his car in July 1917. As the tires were quite expensive, he placed an advertisement in the *New York Times* offering a reward for them.

Three

HOMES

Architecturally, St. James has been blessed by the presence of more than one important architect. But early in its history, most homes were not designed: they were built by craftsmen who had little education and little experience. Few of the very earliest homes still stand. Most were lost to fire or simple changes in taste; it was not uncommon to replace an older home with a more modern building if the family had the means to do so. By the mid-19th century, St. James had in place two important buildings designed by professionally trained architects: the Mills Pond House, designed by Calvin Pollard, and the St. James Episcopal Church, designed by Richard Upjohn. As the 20th century approached, architects like Archibald Brown, Stanford White, Isaac Henry Green, and Lawrence Smith Butler began to change the kind of buildings that were erected in St. James. Elegant estates, attractive retail structures, and all sorts of modern support buildings dramatically changed the face of this small farming community. Outside developers such as the House and Home Company took advantage of the "ease of access" the railroad provided and also did the same, not for the wealthy, but for the common man.

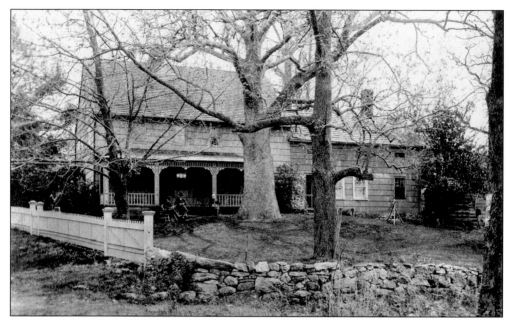

THE TIMOTHY MILLS HOUSE, C. 1898. Timothy Mills built this expansive house for his son Isaac (1697–1767) around 1750 on the shore of Mills Pond. In the following century, Thomas Helme Mills (1790–1847), Isaac's great-great-grandson, lived in the house with his Smith bride, Martha (1792–1864). The look of the house changed in the late Victorian era, with the addition of a pair of conical-roofed turrets. Owners over the years have included the Powells, Brennans (forebears of John N. Brennan, Smithtown supervisor), and Doughertys.

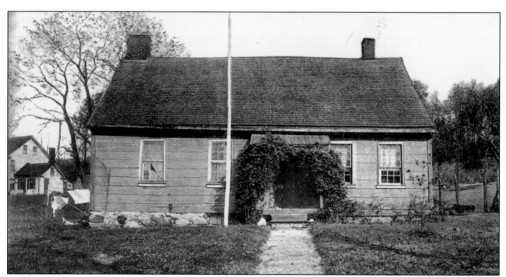

THE HOME OF JOB SMITH, C. 1900. Job Smith (1719–1780) was a descendant of the bull-rider Richard Smith. He built this home on Harbor Hill Road around 1776 for his son Charles, who was born in 1756. It is one of the area's oldest residences still standing on its original footprint. It passed to Capt. Job Smith (1799–1849) after his father's death, and then to his widow, Sarah (1805–1875), who lived and ran a store (in the north end) there. Its association with George Washington is likely apocryphal.

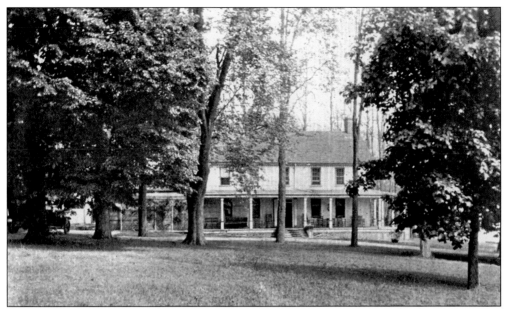

CAPT. OBADIAH F. SMITH HOUSE, C. 1910. Obadiah Francis Smith (1818–1924) was one of St. James's longest-lived residents, achieving the age of 106 years. The house was built around 1860 for him and his bride, Sarah Davis (1840–1926). William Gleichman, owner of many St. James properties, acquired the house prior to 1917. Today the house remains in good condition.

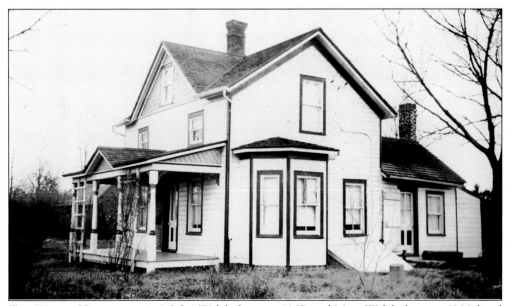

THE WELCH HOUSE, C. 1915. John Welch, born in 1865, and Mary Welch, born in 1866, lived in this farmhouse, located on the south side of North Country Road. Welch was a farmer and a gardener. Beyond the trees on the right was the residence of coal merchant Truman Davis, born in 1866. The Welch house no longer stands.

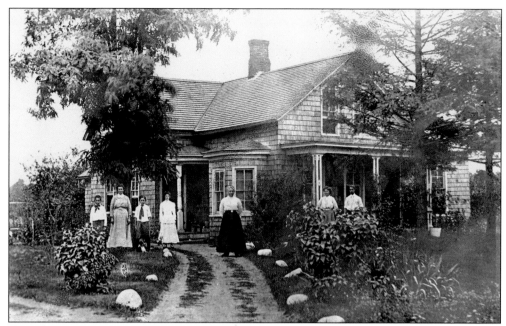

THE HOHWIELER HOUSE, C. 1908. Of German extraction, the Hohwielers were among many northern European families who arrived in St. James. The house, an older home with a c. 1850 addition, was occupied by Dora Hohwieler (1866–1941) and her family by 1917. It is one of very few residences that still stand on the now commercial North Country Road.

FLOYD SMITH'S HOUSE, C. 1910. This late-19th-century Victorian home (right) is located on Moriches Road just south of the Methodist Episcopal church. Floyd Gideon Smith (1870–1934), the son of Gideon (1808–1892) and Sarah Rudyard Smith (1831–1895), resided here. The house still stands today, although somewhat altered. In the left background is the house of Charles Edmund Smith (1851–1927).

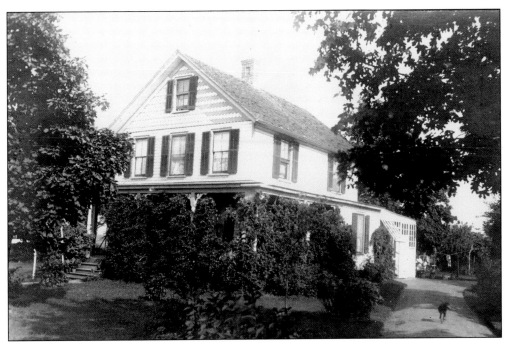

THE JOSEPHUS CARMAN HOUSE, C. 1890. Josephus Carman, born in 1850, was the youngest son of "the shipbuilder" Samuel Carman. A carpenter by trade, Josephus helped build many houses in St. James, including those of his sisters. This house stands today, near the entrance to the Butler-Huntington Woods Nature Conservancy.

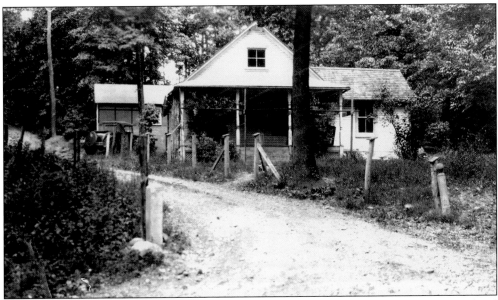

THE LUTZ HOUSE, C. 1930. Charles Lutz, born in 1871, and his wife, Julia, born in 1878, lived in this little cottage on Overton's Pass. Lutz was a wagon driver for one of the many estates on large farms in the area.

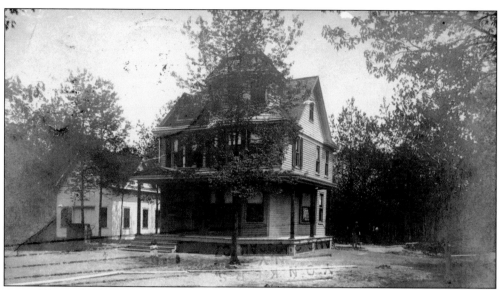

AUNT HATTIE'S HOUSE, 1907. The Nagle family wrote a great deal of postcards during the first decades of the 20th century. This card depicts a late-Victorian residence and barn, mentioned as the home of "Aunt Hattie," probably that of Harriet Hilliker, who was born in 1862 or 1867, located on Fourth Avenue in St. James Park. Hattie Hilliker ran a private school that was mostly attended by local girls, although Bud O'Berry went there for a short time. The house and barn no longer stand today.

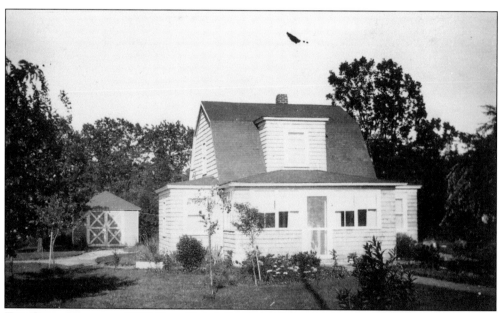

THE QUIST HOUSE, C. 1917. Peter Quist's (1866–1936) home, with its gambrel roof, wings, and glassed-in porch, was not atypical in St. James. It still stands on Jefferson Avenue today. The early garage (left background) was also typical. Henry Quist (born in 1862), a carpenter and perhaps Peter's elder brother, lived with his family on Second Street.

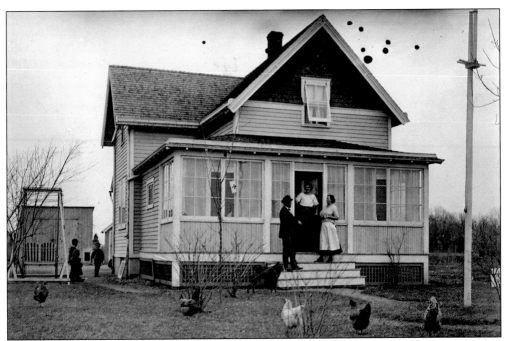

THE HOME OF MARY NELSON, C. 1920. Located at the northwest corner of Woodlawn and Cambon Avenues, this house was the home of Mary Nelson, a laundress who was born in 1876. She was the wife of Victor Nelson, born in 1865, a native of Denmark and a carpenter by trade. The house, with its wooden seat-swing and glassed-in porch, no longer stands.

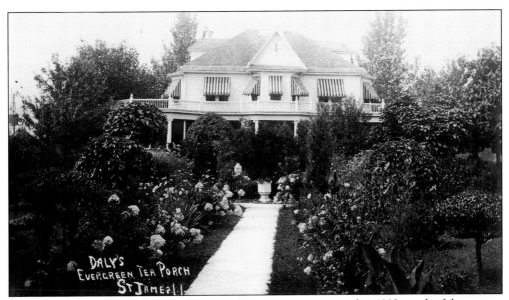

THE C. F. WELLS HOUSE, C. 1910. This grand home was constructed in 1903, north of the present elementary school, for Long Island Rail Road station master C. F. Wells. It bordered the property of Father Ducey and Mayor Gaynor. Later owned by E. F. Wells, it eventually became Daly's Evergreen Tea Porch, run by former vaudeville stars Charles and Kitty Daly. Now divided into apartments, the house looks much the same today except for the loss of the expansive front porch.

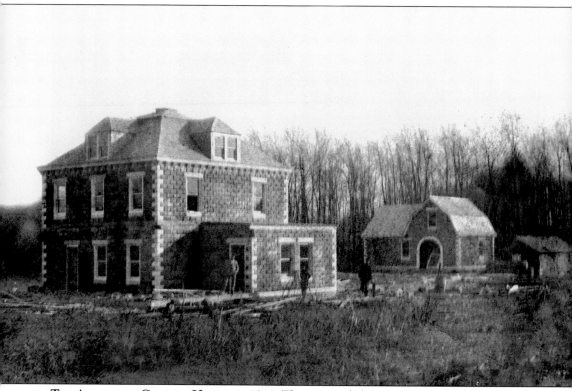

THE ARCHIBALD GRAHAM HOUSE, C. 1910. This postcard photograph was sent to local resident and vaudeville performer John Barton by his friend and soon-to-be-neighbor Archibald Graham (1874–1944). Graham was building his new and innovative concrete block house nearby and wanted Barton's opinion. One of the best golfers of the era, Graham was born in New Jersey and became the first amateur golf champion in that state (1900) and participated in the U.S. Amateur and Metropolitan Golf Association championships. After residing here for several years, he moved from St. James to Blue Point, and his home was acquired to become part of the McLean Estate. Greatly expanded and altered, it still stands on the south side of Three Sisters Road.

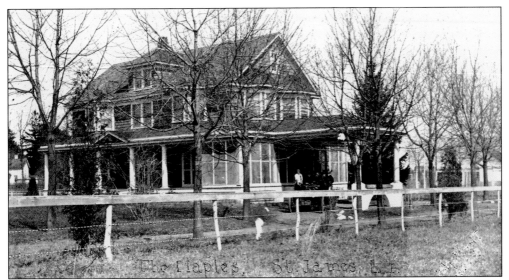

THE MAPLES, C. 1920. This large Colonial Revival home, with its distinctive port cochere, is located along North Country Road near the intersection of Northern Boulevard (this end of Northern Boulevard used to be called St. James Avenue). The house was owned in 1917 by Mrs. S. Herdick, of whom little is known.

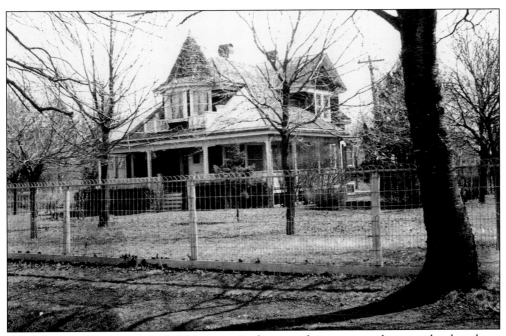

THE WIDOW'S HOUSE, C. 1920. This attractive house with its semicircular turret has long been a favorite of many St. James residents. It is located on the south side of North Country Road, near the corner of Northern Boulevard. One photograph refers to it as "the Widow's House." Later it housed the Bluebird Tea Room, run by former vaudevillians Terence and Libbie Burns.

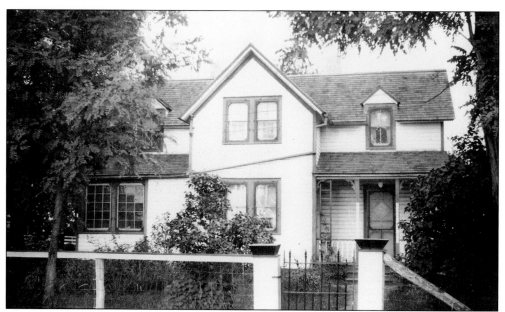

THE AMEY HOUSE. This residence was one of many in St. James either built or owned by Joseph Amey, who was born in 1873. Amey was very active in developing real estate in St. James. He built the feed store and the Flatiron Building, both located on Railroad Avenue. He was also the local revenue agent, responsible for finding the illegal liquor both made on Long Island and brought in during nighttime landings on the many bays and inlets during Prohibition. The 18th Amendment and the Volstead Act made alcohol (including beer, wine, or other intoxicating malt or vinous liquors) illegal in the United States from 1919 to 1933.

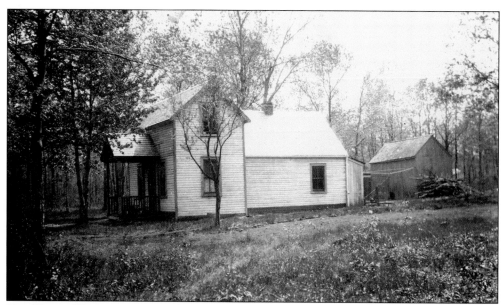

THE KNAPP HOUSE, C. 1920. Edward Knapp, born in 1877, was a wagon driver for one of the local farms. This house was located on First Street, and although small, it was the home to Knapp, his wife, and their four children. The lot was heavily wooded, as land in Boomertown was not cleared prior to being divided for sale.

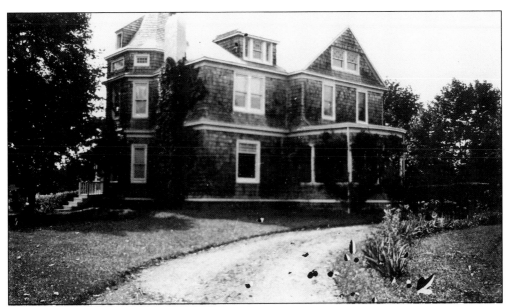

THE FLINN HOUSE, C. 1920. Sarah Flinn was able to acquire what was at the time one of the finest homes in St. James. It is one of two sister houses on the west side of Highland Avenue, both built by George S. Hodgkinson (1860–1928). With their distinctive turrets, or towers, the houses displayed the prominence of their owners to the local community. This house looks much the same today and is currently being renovated.

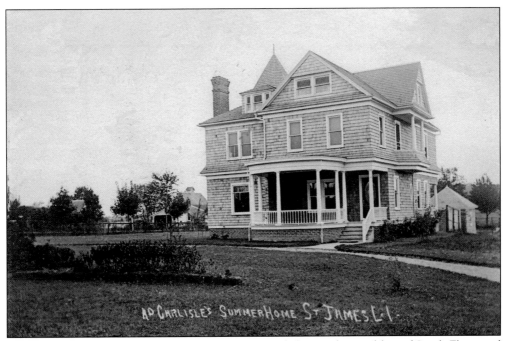

THE CARLISLE SUMMER HOUSE, C. 1915. A. D. Carlisle was the neighbor of Sarah Flinn and lived in the other sister house located on Highland Avenue. The beautiful curved entrance drive is highlighted by surrounding decorative floral beds. In the left background is a barn that is likely part of the Timothy House complex.

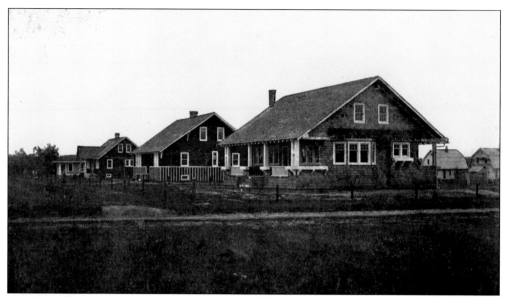

The New Bungalows, c. 1917. This series of bungalows was constructed by a man named Ellis on the block in St. James Park bordered by 1st Street, Sixth Avenue, 2nd Street, and Fifth Avenue. The block included eight houses, all of which seemed to have been built on speculation. It certainly paid off, as by 1930, the area was heavily populated by the farm and estate workers who used to live in the newly incorporated villages of Head-of-the-Harbor and Nissequogue. Today many of these houses have been renovated or altered.

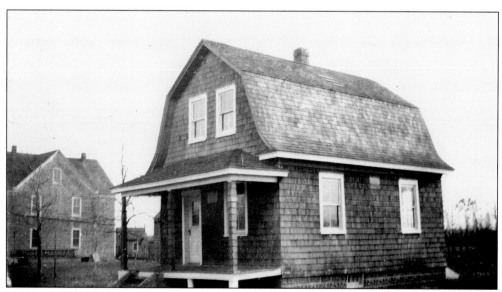

House on Jefferson Avenue, c. 1925. This Gambrel-roofed cottage was built on Jefferson Avenue. These very small cottages were often the first homes for the many immigrants who came to St. James in the early part of the 20th century. Very few of these homes remain unchanged today.

THE JENSEN HOUSE, C. 1930. Fred Jensen, born in 1893, was like so many in St. James, an immigrant from northern Europe, in this case Denmark. An estate laborer, he lived in this house on Sixth Avenue with his children (near the fence) Julius, born in 1919; William, born in 1922; Elna, born in 1926; and Esther, born in 1928. Hundreds of Danish, Norwegian, and Swedish families came to St. James during the early 20th century.

THE LOVE NEST, C. 1925. The photograph of this small, square house is entitled simply "the Love Nest." The smaller houses in St. James, such as this one, are disappearing fast today.

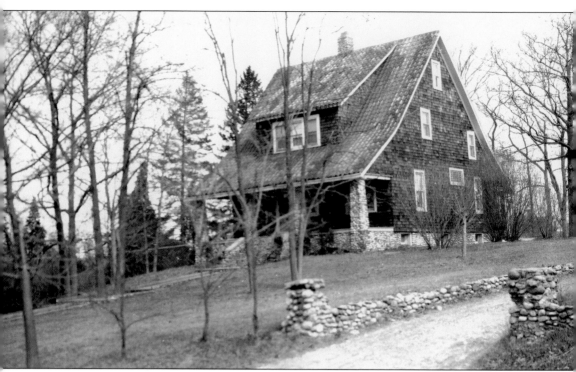

THE KAISER (HODGKINSON) HOUSE, C. 1925. Located on the corner of Highland Avenue, this home was the second residence of George S. Hodgkinson (1860–1928), who built many of the houses on Highland Avenue. His earlier residence still stands on the west side of Highland Avenue near North Country Road. By the mid-1920s, it was occupied by the Kaiser family, possibly Franc Kaiser and his wife Emily, born in 1858. Born in France in 1858, Franc was a glass engraver. The home was purchased around 1943 by Frank (1894–1985) and Isabelle Goehle (1907–1989), who made it their home for many years. The house had a distinctive high-pitched tile roof (now lost) and elaborate stonework.

Four

BUSINESSES

From its earliest existence, St. James was a place where numerous businesses could thrive. By the time of the arrival of the railroad, St. James had seen nearly every type of business imaginable—early records reveal there were general stores, butchers, saw- and gristmills, a tannery, a shoe factory, a whiskey distillery, ship builders, blacksmiths, and a host of other businesses in the area. With the railroad providing easy access to all points west, new businesses began to grow in the area by the late 19th and early 20th centuries. Flowerfield became one of the largest and relied heavily on the railroad to deliver its bulbs far and wide. Soper's bottling works grew into a successful industry that sent its "refreshing" goods all over Long Island. Hotels and boardinghouses helped to invite new people into the community, which helped foster the need for workers and new employment opportunities. Smaller businesses also helped to grow St. James; those who worked as painters, carpenters, plumbers, and laborers all made an important contribution to the community.

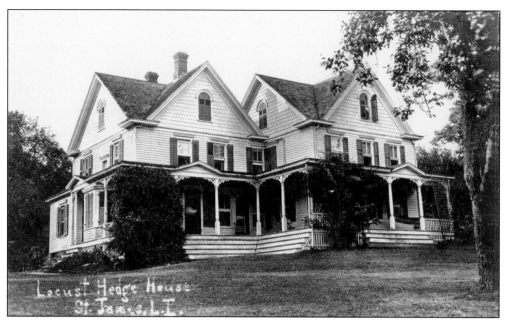

LOCUST HEDGE HOUSE, C. 1910. With the influx of summer renters and vacationers, both hotels and boardinghouses became part of the landscape. For those who could not afford a hotel, a simple room at one of the boardinghouses, such as the Locust Hedge House, was a welcome relief after a long journey.

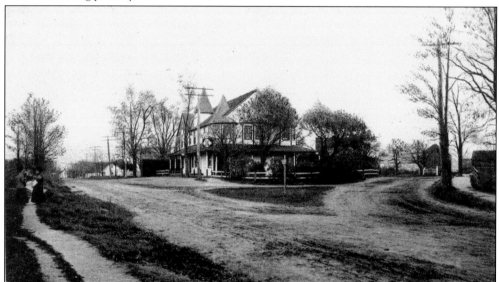

GOULD'S HOTEL, THE ST. JAMES HOTEL, C. 1920. This mid-19th-century building, one of the first modern hotels in the area, was located on the triangular green opposite the present St. James Firehouse. Originally a simple gable-ended structure, the building was expanded and made more Victorian around 1900. Owned by Samuel A. Gould (born in 1860) by 1917, the hotel served the many actors and vacationers who had helped make St. James a thriving summer resort. (Gould's house, a few buildings east, became the McMackin Real Estate office and burned in December 1981). By the 1960s, the hotel was serving as the Gold Coast Two, a popular restaurant and bar. The building was destroyed by fire in the late 1970s.

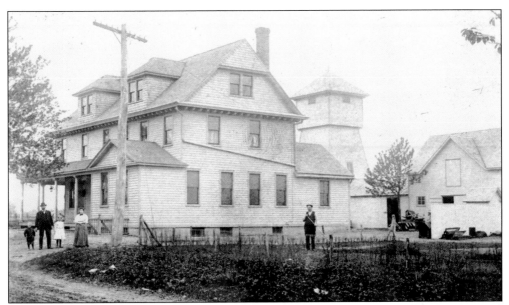

THE NISSEQUOGUE HOTEL, C. 1910. Completed in 1905 on the corner of Lake Avenue and Railroad Avenue, the hotel was built to fill the need for rooms for all the summer visitors who were coming to St. James. During the summer, it was filled with vacationers who hired carriages to take them to the beach; in the fall and winter, it was the headquarters for anyone who wished to do a bit of hunting in the area. Mrs. H. L. Moore was its owner and manager in 1917. The building was one of the last of its kind when it was destroyed by fire in December 1962 (by this time it had been renamed the St. James Hotel).

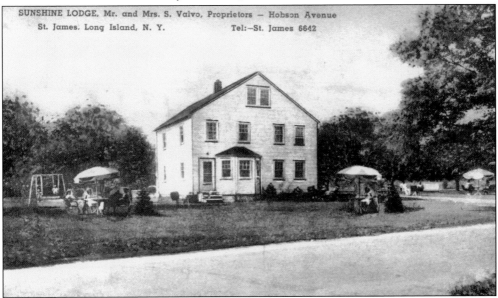

SUNSHINE LODGE, C. 1940. Like so much of Long Island, St. James remained a popular summer destination throughout much of the 20th century. Even after the initial rush to open hotels in St. James, later residents continued to offer more intimate lodging for visitors. The Sunshine Lodge was located on the west side of Hobson Avenue, near its intersection with Oak Street, and was operated by the Valvo family. Today the building is a private residence.

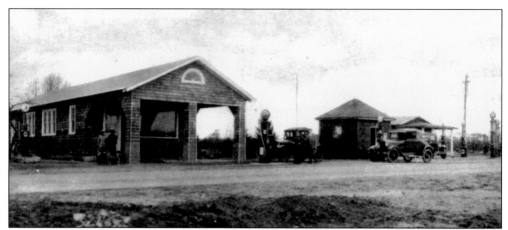

GUS HUBER'S GAS STATION, C. 1920. Huber's was one of the earliest of the gas stations on the north side of Middle Country Road. Gus Huber, born in 1893, was trained as a blacksmith and eventually became a real estate broker. Despite all the commercial development on that road, the original building still stands, recently having been occupied by a sign company.

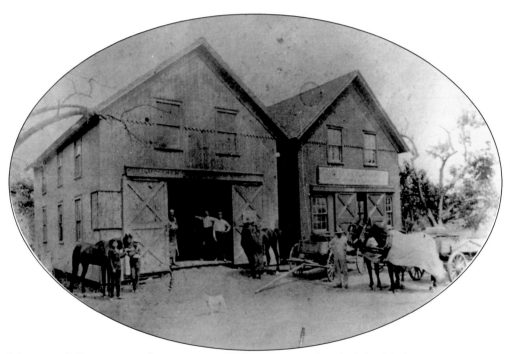

MONAHAN'S BLACKSMITH SHOP, C. 1910. William H. Monahan built his blacksmith shop on the east side of Moriches Road near the intersection of Moriches and North Country Roads. Basically a large barn, the building serviced the blacksmithing and other supply needs of the community for decades. By 1917, the shop had been enlarged to include two structures located side by side and Monahan had hired an assistant, George Gentry, born in 1851. One of the most successful local businessmen, W. H. Monahan owned large tracts of land as well as small parcels throughout St. James. His shop was closed for many years prior to being destroyed by fire in the 1970s.

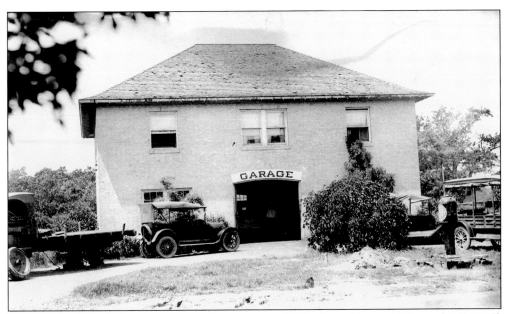

O'BERRY'S (PENNEY'S) ST. JAMES GARAGE, C. 1915. John Henry O'Berry (1883–1937) established his new automobile garage on North Country Road, diagonally opposite the 1908 schoolhouse, in 1912. The large two-story brick building was designed by local architect Lawrence Smith Butler. Along with Huber's on Middle Country Road, it was one of the few local gasoline and repair stations. The O'Berry family continued to operate the station through the 1960s. Currently named Penney's Garage (after owners Betty and Platt Penney), it is still in operation under Will Dowling.

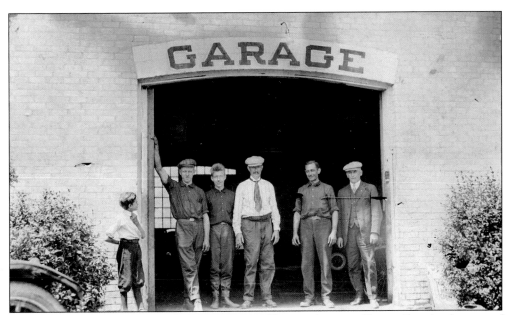

THE WORKERS POSE, C. 1918. O'Berry is pictured here with some of his staff in the doorway of his new automobile garage. It became one of the busiest places in town, as more and more locals acquired those "newfangled" automobiles.

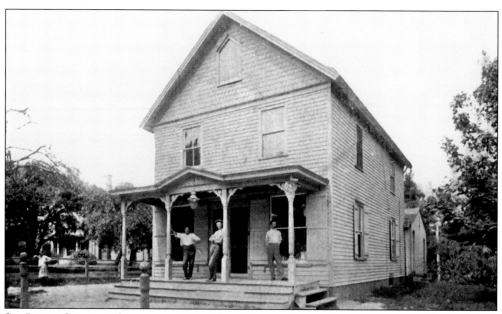

ST. JAMES GENERAL STORE, C. 1900. The oldest continuously operating general store in the United States was first opened in 1857 by Ebenezer Smith. In 1890, the building was relocated to the rear of the site and enlarged. The store serviced a wide range of the community, from farmers to estate owners and actors. The post office was located here for years. Everett Smith was a later owner, as was Andrew Havrisko (1915–2005), who carried the business forward in modern times. John and Eleanor Oakley were the last private owners. In July 1990, with funds from New York State, Suffolk County purchased the store and took over its operation. Actor James Earl Jones shot a Bell Atlantic commercial on the front porch in the mid-1990s.

WILLIAM F. WEBER'S GROCERY STORE, C. 1920. Weber's store was located on the corner of Hobson and Woodlawn Avenues. Weber, born in Germany in 1871, immigrated to America in 1889 and became a citizen in 1912. Known locally as the Woodlawn General Store, Weber's stocked many of the daily necessities. This building was still used as a store through the late 1970s, when owned by George DeCamp. Today the building is being converted to a residence.

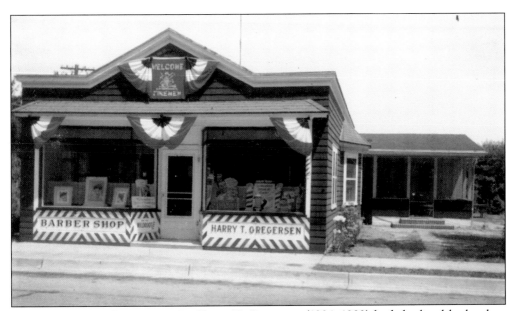

HARRY'S BARBER SHOP, C. 1950. Harry T. Gregersen (1904–1980) had the local barbershop at the corner of 5th Street and Lake Avenue. Any boy worth his weight ended up there for his regular haircuts. Gregersen was born in Norway and was a celebrity in St. James; he was a noted skiing enthusiast and departed one day in 1960 to be a judge at the Winter Olympic Games at Squaw Valley. The tradition begun by Gregersen over a half-century ago continues today at this barbershop under the ownership of Tom Honkanen.

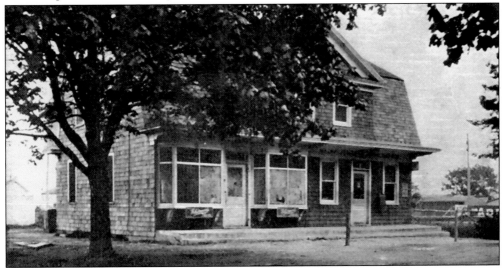

MONAHAN'S STORE, C. 1920. The original building was constructed and owned by local blacksmith William H. Monahan. The post office moved into the building in 1913. Percy A. Land (1885–1950) acquired the building for his lumber business in 1924. It was purchased in 1950 by William "Pop" (1909–1981) and Ava Noftsinger (1909–1984), who opened it as the St. James Hardware Store, later operated by their daughter Valinda Noftsinger DeMato. In the late 1990s, Valinda changed the store from hardware to antiques, opening Valinda's Obsessive Collective, an antiques shop. Recently, entrepreneur Pat Mazzeo (who restored the old school) bought the building and renovated it. Today it is occupied by an antiques shop and decorating company.

THE FLATIRON BUILDING, C. 1910. So called because it is shaped like an old-fashioned flatiron, this building was erected in 1908 by Joseph Amey and was owned by H. F. Bisbee during the early 1900s. The Long Island Lighting Company opened a substation next door by 1917. This building also housed the one-lane bowling alley, a favorite of locals in days past. From the 1920s through the 1940s, it housed a soda fountain operated by Larry and Nellie Smith and was later known as O'Keefe's. To buy a paper in St. James during that period, one either went to Smith's or across the way to Riis's Store. By the 1960s, the building was occupied by the local bakery, and today it is home to the Dowling-Knipfing-Klein Insurance Agency.

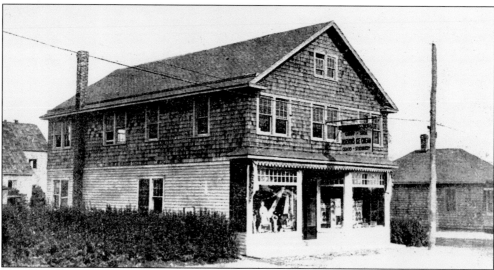

THE RIIS BUILDING, C. 1920. Emiel Riis, born in 1875, operated his barbershop and soda fountain in this building for many years. He moved to the building from one located across the street in the 1930s. He worked in the front and lived in a small apartment at the rear. He set up tables at the back of the store so local men could play cards. Later he enlarged the building, adding a small shop to the north, occupied by Hankervitch's Barber Shop (later owned by Lou Shaw). In recent years, the building was occupied by Extebank followed by North Fork Bank. Currently, it is a doctor's office and nail salon. The building in the left background was another of the local "halls," or meeting places that no longer stand.

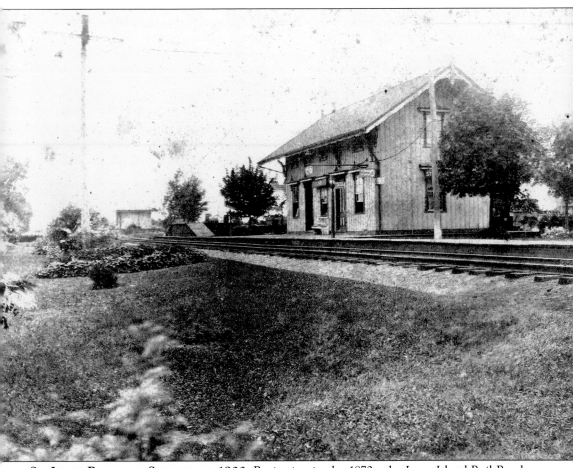

St. James Railroad Station, c. 1900. Beginning in the 1870s, the Long Island Rail Road began the construction of elegant new stations across Long Island. The St. James Station, finished in 1873, was one of the earliest. Constructed in what was known as the Steamboat Gothic style, with wide eaves, large brackets, and elaborate decorative moldings, it quickly became one of the show buildings of the community. It was built by local carpenter Calvin L'Hommedieu. To the west of the station house, the freight-baggage station once stood. In the 1960s, many stations were torn down by the Long Island Railroad, as operating costs soared and more and more commuters bought tickets on board trains instead of at stations. Poorly maintained for years, the station was finally restored to its former glory in the early 1990s.

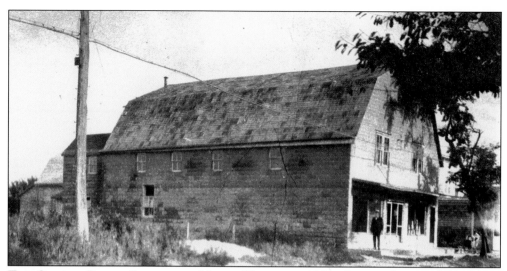

THE CEMENT BLOCK STORE AND MOVIE HOUSE, C. 1910. Cement (concrete) block was popular in the early part of the 20th century when it became possible to cast cement with decorative shapes and finishes. Sears, Roebuck, and Company sold a hand press to create "fancy" concrete blocks. This commercial building, larger than others of that period, was built in 1907 by Albert Wolf. It was then acquired by William Wanzer and then by Huntington real estate broker William B. Codling, who was born in 1856 and sold many homes in St. James during the early 1900s. The building housed the first St. James Movie Theater on the second floor, and Wesley Wolf, born in 1899, was a motion picture electrician there. After moving to Second Street, the theater occupied one other building before the Calderone Theater (closed since the 1950s) was built. The 1910 Meyer Building (right) still stands next door.

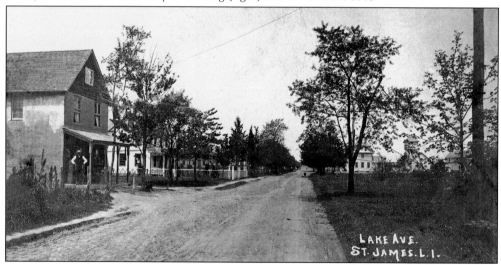

BUSINESSES ON LAKE AVENUE, C. 1906. This image is easy to date as the Nissequogue Hotel (built 1905) stands in the right rear of the image yet the Cement Store (built 1907) does not yet stand south of it. This view is looking north. The rural nature of St. James is plainly evident. The store on the left is that of Lucius Rafter, born in 1866, one of the local house painters. The neighboring house, to the north, is Albert Wolf's (born in 1860) Real Estate office (later to be occupied by W. B. Codling) with its sign "Real Estate—Houses to Let—A.B. Wolfe." Between the trees, one can just about make out the Long Island Railroad Station.

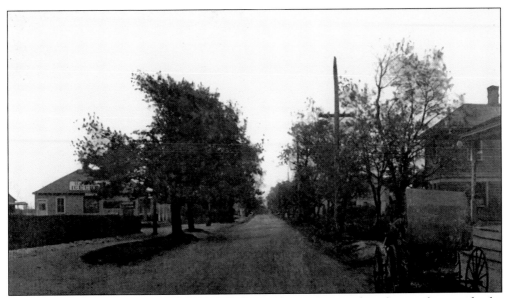

LOOKING SOUTH ON LAKE AVENUE, C. 1909. This image is taken from right outside the Flatiron Building looking south along the avenue. The small house on the right (just south of the Flatiron Building) was owned by Joe Amey and disappeared when the parking lot for what became King Kullen was enlarged. Riis's Ice Cream Shop (left) was owned by C. M. Smith and still stands today as one of the local bars.

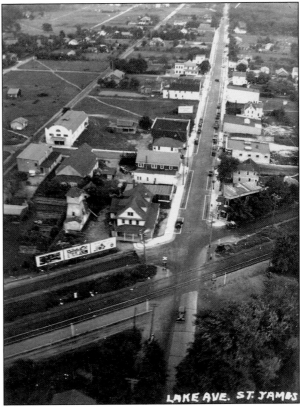

AERIAL VIEW, C. 1927. This is a particularly important shot as it reveals how St. James has been transformed over the years. Calderone's St. James Theater (left, center) is shown on the corner of Second Street and First Avenue. On the right, Second Street actually goes through to Railroad Avenue where King Kullen stands today. One is struck by how much land is either vacant or completely wooded. It is an image in stark contrast to today.

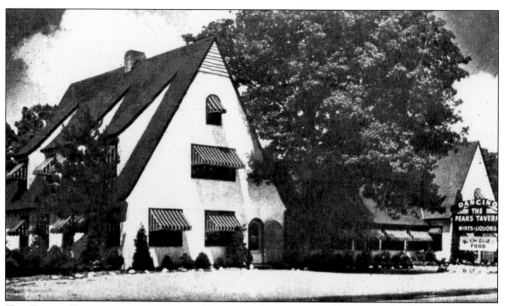

THE PEAKS TAVERN, C. 1940. One of the more distinctive buildings on Middle Country Road at the corner of Hobson Avenue, it derived its name from the extremely elongated and narrow peaked roofs located at either end of the building. Over the years, the businesses that occupied the tavern and its exterior decoration have changed. At one time, the building was Ling Ling's Chinese Restaurant, with bright white and black trim; today it is another Chinese and Japanese restaurant. When it was the Peaks, it was known as the fanciest restaurant in town.

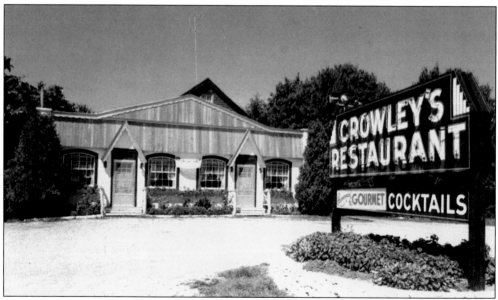

CROWLEY'S TAVERN, C. 1960. Who could ever forget Crowley's Tavern, or as it is better remembered, the Frog and the Peach Restaurant. Located on the corner of Middle Country Road and Astor Avenue, the restaurant was extremely popular for decades. Louis Mautone, the author's grandfather, once went there to eat and sent his pasta back 11 times because the cook could not make it al dente. Needless to say, he was asked to leave before he could place a 12th order. Today the building is occupied by the Villa Sorrento Italian Restaurant.

Five

VAUDEVILLIANS

It is impossible to imagine how cosmopolitan St. James must have been during the first quarter of the 20th century. This is certainly due in large part to the presence of the stars of Broadway and the vaudeville stage. One may never truly know how many stars of the stage visited St. James—the number is perhaps in the thousands. But it is interesting to look at the large number who did not make St. James just a summer place, but rather were here on a more permanent basis. People like Terence Burns (1879–1934), who along with his wife Libbie, born in 1883, starred on stage as the team Burns and Frances. Burns became secretary of the St. James Board of Education and treasurer of the Smithtown Democratic Club, and he died here years after first arriving in St. James. In addition to those discussed on the next few pages, other notables include Charles Bigelow, born in 1861; the dramatic actor J. Harry Jenkins, born in 1876; George, born in 1863, and Lillian Paige, born in 1869; noted director and performer Frank Brownlee (1874–1948); and the "legitimate actor" Michael Heckert, born in 1861, and his wife Sallie Stembler (1872–1944).

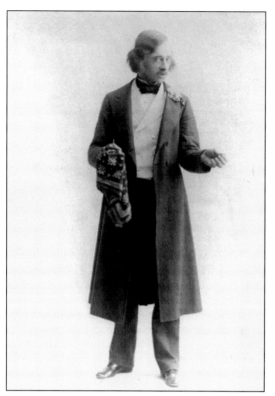

WILLIE COLLIER IN COSTUME, C. 1890. William "Willie" Collier (1864–1944) was one of the earliest vaudeville actors to reside in St. James. The area at one time was even known as Collierville for the all the actors who owed their arrival in St. James to Willie. Collier starred in such successes as *On the Quiet* (1901–1902), *Twirly Whirly* (1902–1903), and *Caught in the Rain* (1906–1907). Both as an actor and screenwriter, Collier was active in filmmaking in Hollywood for three decades. Collier was the stepfather of Willie "Buster" Collier Jr. (1902–1987), who had a successful movie career alongside his stepfather during the 1920s and 1930s.

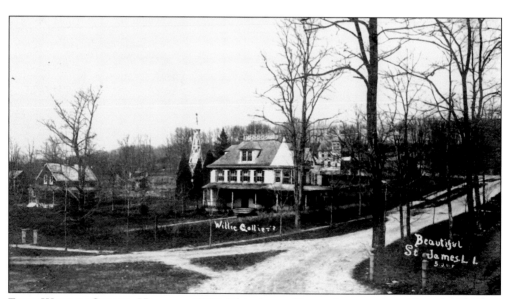

FIRST WILLIAM COLLIER HOUSE, C. 1900. This elegant Queen Anne–style residence was built at the corner of Three Sisters and Harbor Roads by noted vaudevillian Willie Collier. Willie was one of the most popular performers on Broadway, and it is through his influence that St. James became an actor's colony. Willie lived in this house with his first wife, Louise Allen Collier, another noted performer. Willie supposedly lost it by divorce and instead moved into a much grander residence on Moriches Road. This house, minus its turret, still stands on its original site.

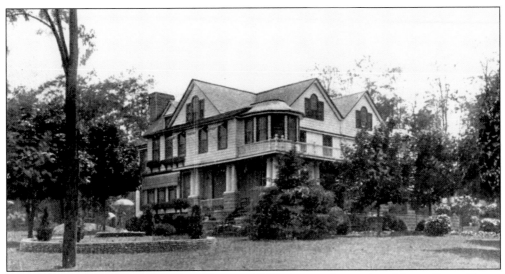

WILLIAM COLLIER HOUSE, SUMMER RUN, C. 1915. Acquired to replace his smaller residence on Harbor Road, this large house was originally built by the Carman family on Moriches Road and was redesigned in what was at the time called the German Beer Hall style. The large covered porches and ample windows made it an inviting retreat from the hard work of the theater. The house boasted, among other amenities, a large billiard room for the use of Collier's guests. After departing from St. James in 1936 for the last time, his residence was sold and owned by various individuals. Over the years, the home has lost its grand porches and today is partially hidden by a large hedge.

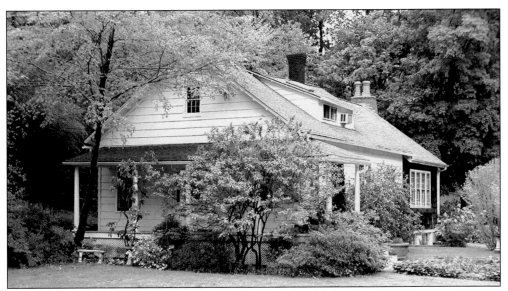

THE OPERA HOUSE. Originally constructed as one of the old district schools between 1837 and 1850, it was acquired by the vaudevillian actor Willie Collier around 1890 and was renovated to serve as the St. James Opera House. Collier and many of his actor friends performed here while summering in St. James, and it was also alternatively known as Liberty Hall. In 1907, it was the first location where Catholic services were held prior to the completion of Sts. Philip and James Catholic Church. Still standing today, the building is now a private residence.

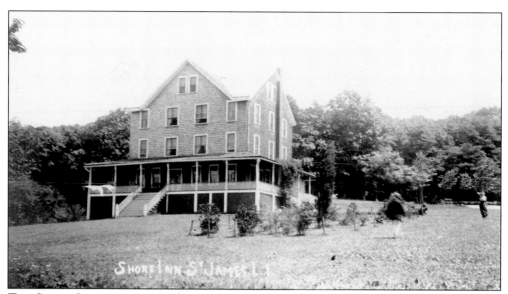

THE SHORE INN, C. 1910. Anthony (1856–1926) and Sophie T. Farrell (1860–1938), retired vaudevillians, ran one of the largest hotels in St. James. The Shore Inn, which opened around 1900, was located on the west side of Harbor Road. With 30 rooms and a long dock and wonderful beach, it was a favorite with vacationers, especially actors from the colony. The first Bohemian Clubhouse was located along the beach nearby. The inn was also noted for its mineral spring, thought to have curative properties. Nearby were a cafe and casino. The Thornton family purchased the inn in September 1917, demolished it, and erected their Little Theater for theatrical performances. The Farrells moved to Patchogue, where they died years later.

THOMAS GARRICK'S HOUSE, C. 1915. Thomas Garrick (1863–1923) was another actor who came to live in St. James. The house, created out of the old Alden L'Hommedieu barn, included a wonderful outdoor stage on which musicians and actors could perform. Garrick, known for stage performances in *The Dictator* and *The Man From Mexico*, was married to Willie Collier's sister, Helena Collier Garrick (1867–1954), who starred onstage with John Barrymore, Marie Dressler, and Lillian Page. Their home was later owned by Thomas Fink. Local lore states that the house was once used by John Barrymore as a residence for his mistress. Expanded and renovated over the years, the house still retains its famous concrete bandstand.

JEROME SYKES, C. 1890. Jerome Sykes (1867–1903) was perhaps one of the most famous stars of vaudeville. The star of *The Billionaire* was a member of a famous family of actors, which included Albert S. Sykes as well. The Sykes family had a summer residence in St. James for many years, part of which was acquired by the Oxnard family in 1907 for their estate. Jerome Sykes was married to Jessie T. Wood, another well-known performer. Sykes died suddenly while on tour in 1903, and his body was placed in the Greenwood Cemetery receiving tomb (vault) until his remains could be brought out to St. James for burial. His family was trapped in St. James by a terrible winter storm and was prevented from attending his funeral in New York.

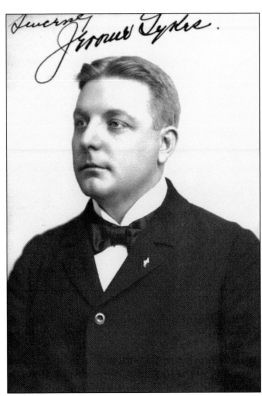

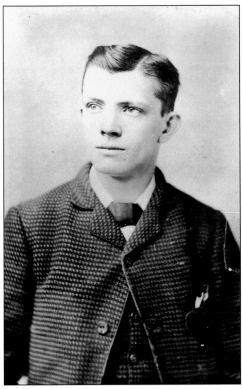

FRANCIS "FRANK" E. MCNISH, C. 1885. McNish (1853–1925) was a popular variety entertainer, acrobat, and comedian who frequently teamed up with the Leland Sisters to form the Jolly Three. Their signature farce was *Stolen Fun*, which they performed throughout the 1880s at venues such as New York's Volksgarten Theater and Tony Pastor's Theatre. Looking young and serious, McNish poses for an unidentified photographer. The McNish family lived in a house on the west side of Highland Avenue for many years. McNish traveled to California to star in a few Hollywood films during the years 1916–1917. He suffered a stroke and died in Chicago, Illinois, in 1925 at the age of 72.

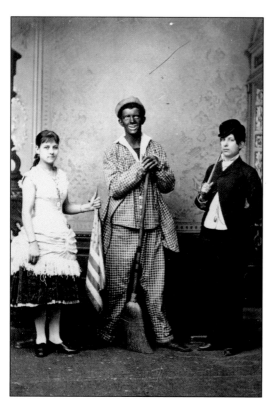

MᴄNɪsʜ ᴀɴᴅ ᴛʜᴇ Lᴇʟᴀɴᴅ Sɪsᴛᴇʀs, ᴄ. 1885. Frank McNish is shown here in blackface with his frequent co-performers the Leland Sisters. Frank fell in love with Rose Leland, and she later became his wife. Her partner, Sophie (1860–1938), ended up marrying Anthony Farrell (1856–1926) and operating the Shore Inn.

Rᴏsᴇ Lᴇʟᴀɴᴅ, ᴄ. 1890. Rose Leland, born in 1866, was a popular performer during the latter part of the 19th century. She fell in love with and married Frank McNish. Their son Frank J., born in 1885, also married a vaudeville actor. In 1904, his son Francis H. McNish died as an infant and is buried in the St. James Episcopal Church Cemetery.

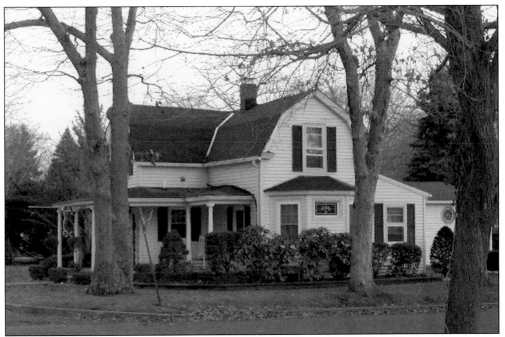

THE BULLA HOUSE. An interesting example of a Greek cross floor plan, the Bulla house was the home to Frederick (born in 1868) and Lillian (born in 1882) Bulla, both of whom starred in vaudeville. Their home is one of the few in St. James Park that still retains a shape and size close to the original design of the building.

BULLA AND GRAY, C. 1900. Frederick Bulla, born in 1868, performed in New York City at Hurtig and Seamon's Music Hall and at the Dewey Theatre, both on his own and as part of the teams Bulla and Raymond and Bulla and Gray. Bulla (left) is pictured here with his partner Harry Gray.

KERNELL'S MONARCH COMBINATION, c. 1885. John (1859–1903) and Harry (1850–1893) Kernell were early vaudeville stars. In 1883, they formed their own company, traveling across the country for several seasons and were known as "the Millionaires of Wit." Following Harry's death, John continued to tour on his own while caring for Harry's children. John had a farm and residence in St. James where he spent much of his time when not performing on Broadway.

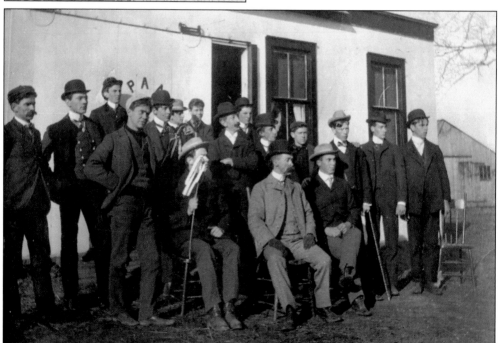

THE ST. JAMES ATHLETIC CLUB, C. 1900. The St. James Athletic Club was an organization mainly associated with the vaudevillians. Everett Smith is seated at center with his dark gloves, while fourth from left in the cap is an older Frank McNish.

JANE WINSLOW, C. 1917. Jane was a great friend of Louise Gardner, a fellow actress. Like so many of her time, Winslow was blessed with talent but not staying power. She often starred in performances at the Bramhall Playhouse, located at 138 East Twenty-Seventh Street. This included roles in *Difference in Gods* and *Keeping up Appearances* (1917).

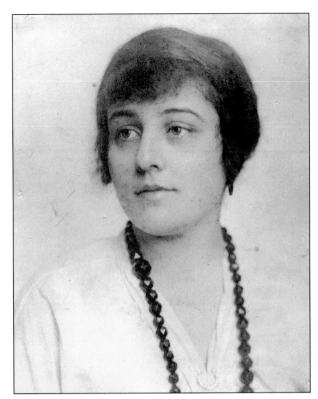

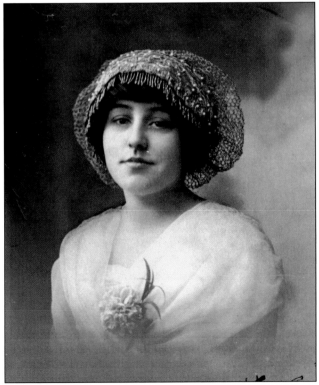

LOUISE GARDNER, C. 1915. Louise Gardner Rodgers (1894–1966) also starred on the stage at the Bramhall Playhouse alongside friend Jane Winslow. Louise fell in love with and married Frederick Rodgers Jr. (1889–1969), son of Adm. Frederick Rodgers Sr. (1842–1917). The Rodgers family owned the estate named High Hedges, located on North Country Road.

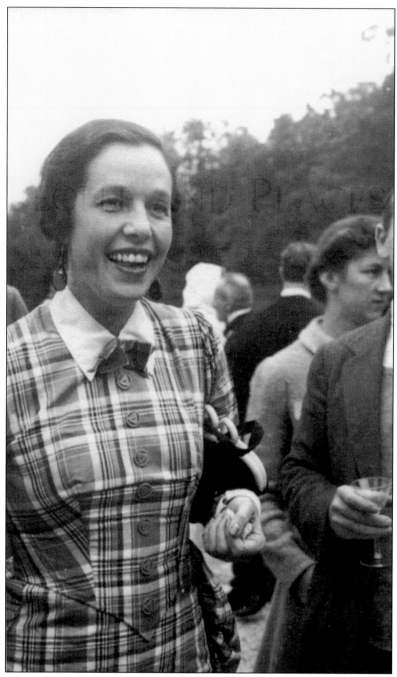

CORNELIA OTIS SKINNER, C. 1950. The noted author and stage actress Cornelia Otis Skinner (1899–1979) was a longtime resident of St. James, having acquired part of the George Zabriskie (1852–1931) estate in 1945. She was the daughter of famous stage actor Otis Skinner (1859–1942). She was married in 1928 to banker and sportsman Alden Sanford Blodgett (1884–1964) and lived with him at their palatial estate until his death. Near the main house was the writing bungalow (destroyed 1987) that Skinner had built around 1930 so she could work in peace and quiet.

Six

PEOPLE AND PLACES

The people are what make any locale, hamlet, village, or town interesting. Sometimes they are odd or ill-dressed, sometimes they are pompous and poorly informed, and still others might be extravagantly wealthy or depressingly poor. Their position or status is not what makes them important to the community—it is their actions and contributions that do. Everyone has at least something to be remembered for, and the few of the many thousands who are pictured in this chapter help define the history of St. James. The same goes for the places that are shown. Each contributes to an understanding of how the community developed and changed over time. Some of them reveal how small St. James once was; others portray the changing nature of the community during its many different periods of history.

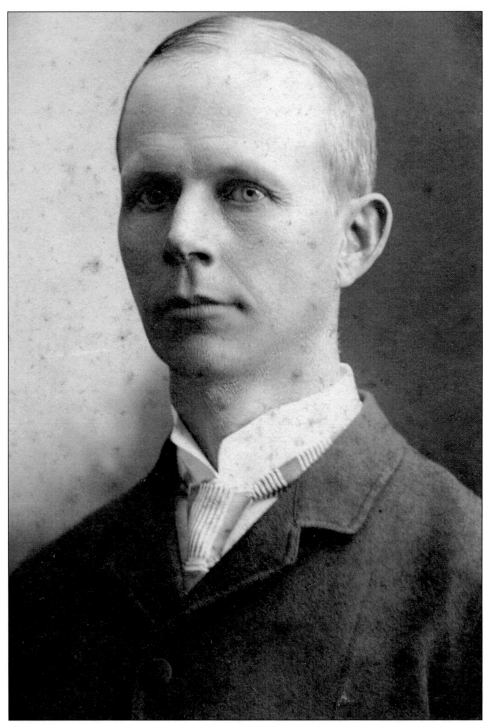

LIVINGSTON SMITH, C. 1890. Smith (1857–1938) was a noted lawyer and later served as district attorney for Suffolk County from 1899 to 1906. He was serving in his position when he had to preside over the notorious trial of Dr. J. W. Simpson for the murder of his father-in-law, Bartley T. Horner of Northport.

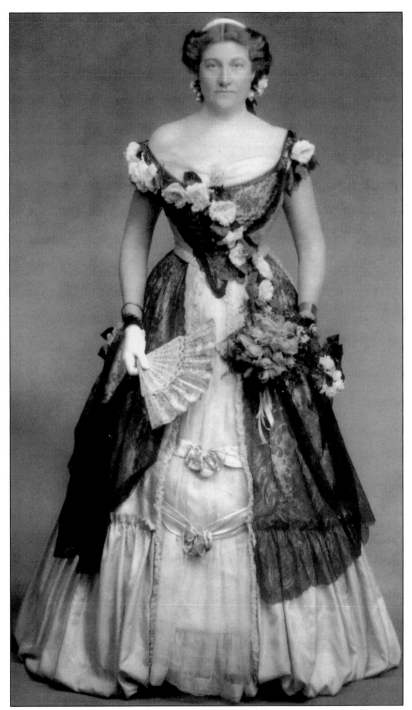

BESSIE SPRINGS SMITH WHITE, C. 1895. Bessie (1862–1953) was one of the A. T. Stewart heirs and the wife of noted architect Stanford White (1853–1906). She had to suffer the horror of having her husband murdered and the public spectacle surrounding his death. She is shown here decked out in a magnificent ball gown with clusters of fine flowers and bows. She survived her famous husband by nearly 50 years.

ELLA B. EMMETT, C. 1888. Dressed in her fine white wedding gown, Ella Batavia Smith appears stern and strong. She was a descendant of the ancient Smith clan and had chosen for her husband noted golf course designer Devereux Emmett. Ella was a voracious acquirer of land in Head-of-the-Harbor and had by 1912 created an estate with nearly 600 acres. Financial losses eventually forced her to sell Sherrewogue, one of the Smith ancestral homes.

DEVEREUX EMMETT, C. 1901. As one of America's leading golf course designers, Devereux Emmett created some of Long Island's most notable courses. He founded the National Golf Links at Southampton and designed St. George's Country Club in Setauket. A small golf course, near the property of Admiral Rodgers in St. James (now lost), was also designed by Emmett. Devereux Emmett served as one of the original partners in the Garden City Company, which developed what became Garden City, Long Island.

THE BUTLER BOYS, C. 1870. Charles Stewart Butler (1875–1952), left, and Lawrence Smith Butler (1876–1954) are shown as young children in the photograph. Both became prominent members of the St. James community, Lawrence as a noted architect and Charles as owner of Branglebrink Farm.

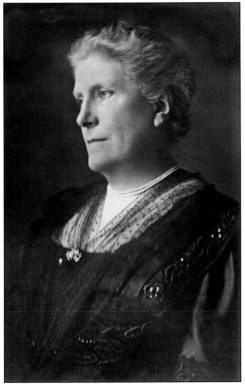

CORNELIA STEWART BUTLER, C. 1910. Born Cornelia Stewart Smith (1846–1915), she was one of the heirs to the fortune created by noted department store magnet and art collector Alexander Turney Stewart (1803–1876). One of America's greatest mercantile geniuses, Stewart founded Garden City and became known far and wide as "the Merchant Prince." He married Cornelia Clinch (1802–1886), who left a great part of her husband's fortune to her niece, Sarah Nicoll Clinch Smith (1823–1890), who in turn left it to her daughter Cornelia and her sisters. An extremely generous and community-minded person, Cornelia Stewart Butler was the great benefactor of the Smithtown Library.

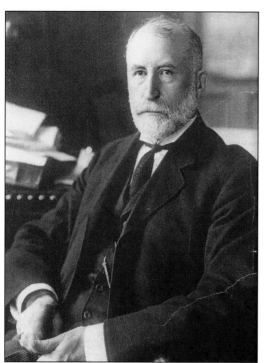

MAYOR WILLIAM J. GAYNOR, C. 1910. William Jay Gaynor (1848–1913) was the owner of Deepwells and was perhaps the most famous summer resident. Born in Utica, he later moved to Brooklyn and served as justice of the New York Supreme Court for the second district from 1893 to 1907 and as mayor of New York City from 1910 to 1913. He made St. James his official residence when not in the city and was always received as a great friend by the community and its residents. Gaynor was shot in the throat by a deranged city employee in 1910 and never recovered. He died from the lingering effects of the wound on September 10, 1913, and was buried in Greenwood Cemetery, Brooklyn. He was the only New York City mayor to be assassinated. Gaynor Park on Woodlawn Avenue is named in his honor.

CLINTON AND FRANK, C. 1910. Clinton Howlett Smith, born in 1888, and Capt. Frank Hart De Mott (1846–1912) pose for a snapshot. De Mott had originally married into the Smith family only to have his wife, Esmeralda (1851–1873), die young. His second marriage, to Carrie Michales, who was born in 1865, did not work out either—she divorced him. Known as "the village philosopher," De Mott later in life lost his large fortune and ended up impoverished. He was a great friend of Mayor Gaynor. When De Mott died in 1912, he was buried in the plot of his wife's family, only to be exhumed per order of the will of his father-in-law, with whom he had had a long-standing quarrel. His body was moved to the pauper's portion of the cemetery, where Mayor Gaynor erected a stone to his old friend that read, "Whatever God's will of me may be, I am content. Frank H. De Mott."

JOHN LEWIS CHILDS. Childs (1856–1921) became one of the leading producers of flowers in America during the late 19th and early 20th centuries. He began with a small flower business that led him to produce seed catalogs. Within 15 years, tens of thousands of his catalogs were being sent around the world, and later his catalogs had an annual circulation over 500,000. He founded the village of Floral Park, Long Island, and had a large home there. By 1917, he had given up most of his holding in that area and acquired 800 acres of land along Mills Pond Road, where he grew many varieties of flowers and bulbs, including gladiolas, dahlias, and peonies. Childs died while returning to New York by train in 1921, and his farm was later sold to the James Mooneys before becoming home to the Gyrodyne Corporation.

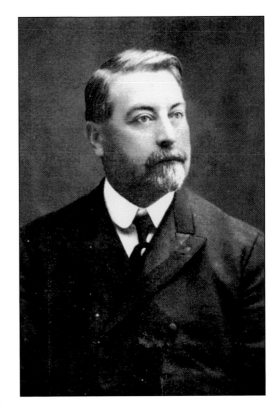

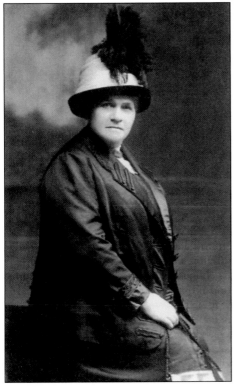

LOUISE A. THORNTON, C. 1910. Louise Clementine Archer Thornton was the widow of Confederate colonel and attorney John Caldwell Calhoun Thornton. Following her husband's death, she brought her family to the East Coast to introduce them (and hopefully marry them) into "polite society." The summer home she built in St. James, Villa Memo, was one of the largest residences ever constructed in the hamlet.

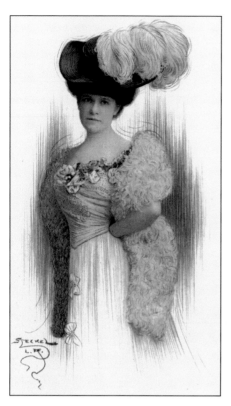

FRANCES DONIPHAN THIERIOT, C. 1900. Frances (1879–1957) was one of the Thornton girls. She was married in a lavish ceremony at the Thornton mansion on June 11, 1912. A special train was chartered to and from the city to ease the arrival and departure of the many guests who attended the wedding. The *New York Times* reported that "the house was decorated with pink and white peonies and wild laurel . . . [and] the bride wore a white chiffon gown with touches of pink, and a large garden hat trimmed with pink roses."

JAMES WARREN LANE JR., C. 1925. James Warren Lane Jr. (1898–1959) was the son of James Warren Lane and Eva Bliss Lane of Suffolk House. He was a graduate of Yale and Harvard Universities and became one of America's leading art historians. During his lifetime, he worked at the National Gallery of Art, was an associate editor of *Art News*, and served as the visiting lecturer of American Painting at New York University. He was the author of *Masters in Modern Art* (1936), *Whistler* (1942), and *Life of Christ in Art* (1957).

REVEREND DUHIGG, C. 1915. Fr. William J. Duhigg was the man responsible for organizing and creating the first Catholic parish in St. James. He arrived in 1907 and quickly set out to raise funds both from the local residents and his friends in the diocese of Brooklyn. The church he founded, Sts. Philip and James, was opened for services in 1909. Duhigg served both this new parish and that of St. Patrick's of Hauppauge before it was mysteriously destroyed by fire in 1927. He died in 1929.

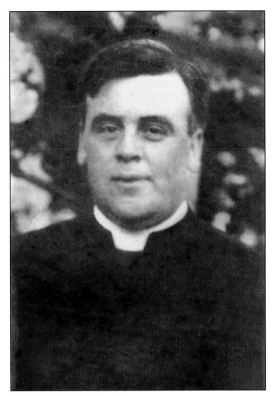

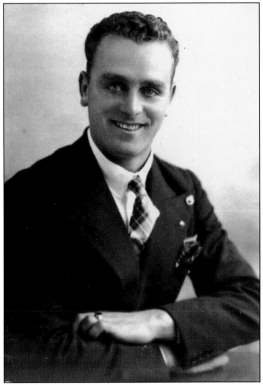

HARRY GREGERSEN, C. 1935. Gregersen ran St. James's most popular barber shop, Harry's Barbershop, during the third quarter of the 20th century. He studied extensively in his native Norway, where he achieved the rank of master barber. Besides operating his business, Gregersen was an avid skier and player of horseshoes, an activity in which he won many prizes.

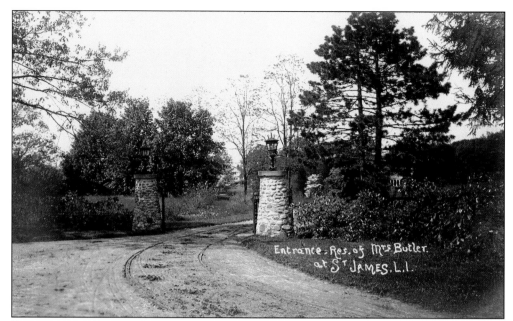

ENTRANCE TO BY-THE-HARBOR, C. 1900. The many estate entrances in St. James that the architectural firm of McKim, Mead, and White were involved in creating all had similar stone piers and walls. This example is on Moriches Road at the entrance to the Butler estate, By-the-Harbor. Stanford White himself took this even further, cladding the original clapboards of his own house in a layer of small stones called "pebbledash."

LAKE AVENUE, 1934. The Smithtown Highway Department is out in force paving the road. This image looks north toward the railroad tracks on Lake Avenue (once known as Gallagher's Lane). On the left are Sam's Meat Market followed by Bergman's drugstore and ice-cream parlor, both of which were replaced by Bohack's Supermarket, later King Kullen. On the right (going north), the new brick store is followed by Riis's Stationery and Barbershop, and the hardware store, on other side of the railroad tracks, can be seen.

THE AVENUE, C. 1909. Lake Avenue was originally a small road known as Gallagher's Lane. By the early 20th century, it had been developed with many fine houses and new businesses. This photograph looks south; the Wells House is at the far right, followed by the property of Father Ducey to the left, and beyond that the property of C. M. Smith. The elegant rows of neatly planted trees have long since vanished from the avenue.

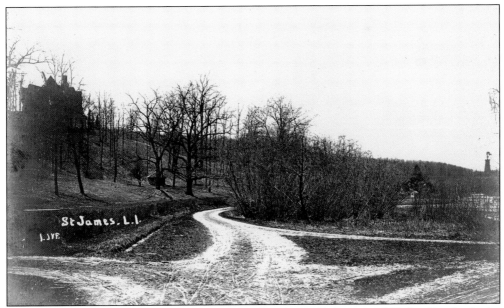

CROSSROADS, C. 1910. This is the intersection of Harbor Hill, Shore, and Harbor Roads. At the far upper left, a silhouette of the Wetherill Cottage can be seen, and at the far upper right is the Butler Windmill in Nissequogue. Notice the early drainage ditch at the lower left.

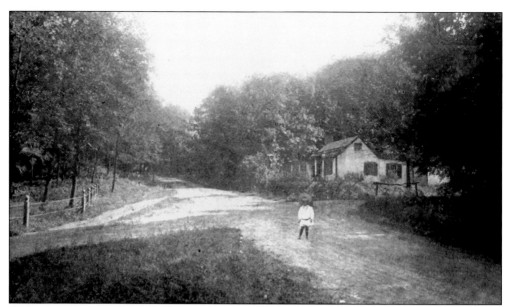

WHERE TO GO, C. 1915. This fascinating image of a small boy posing in the middle of the road could almost have been taken anywhere near the bay where the roads roll up and down very irregularly. In fact, it was taken on Harbor Road.

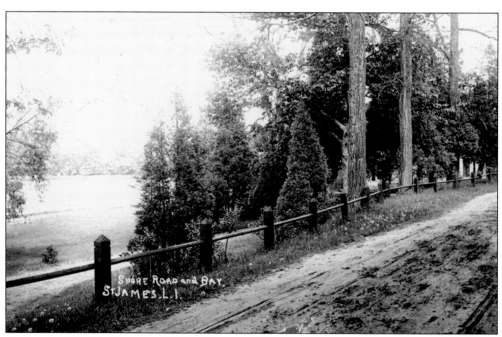

ALONG THE SHORE ROAD, C. 1906. The natural beauty of St. James was a major attraction for many who visited and came to live here. This image depicts the Shore Road prior to paving. This view is looking east across the bay toward Harbor Road.

Seven

FARMING

As in most places on Long Island, farming was the primary activity in St. James up to the 1960s and 1970s, when land started to became valuable enough to merit extensive development. In the mid-1970s, St. James was surrounded by farms, nearly all of which have been now turned into housing developments. Around 1900, there were many poultry farms and dairies all over the community. As the great estates were developed, many of them included farms that supplied produce both for sale and for use by the estates. Branglebrink, one of the largest dairies in town, is remembered for its wonderful ice cream, which was delivered to stores throughout the area. Shellfish and cordwood were naturally occurring commodities that local residents relied on for income.

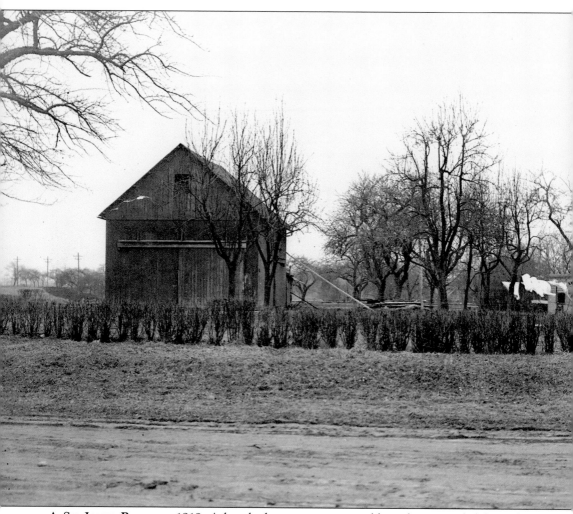

A St. James Barn, c. 1918. A hundred years ago, one could not have traveled far without running into multiple barns and farm buildings. Today it is difficult to find a barn without really searching for one. This simple yet elegant one was located on one of the dozens of farmsteads surrounding St. James.

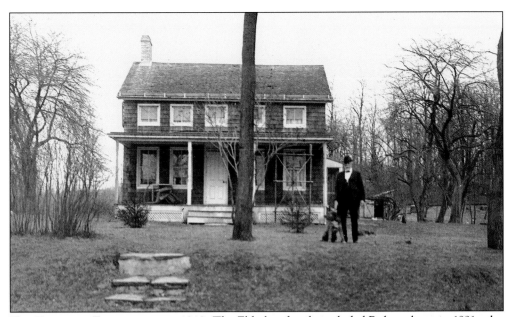

THE ELDERKIN FARMHOUSE, C. 1918. The Elderkin family included Robert, born in 1891, who was a meat peddler, and Lawrence, born in 1890, who drove a coal truck. The Elderkin Farm, where Robert had his business, was located on the east side of Mills Pond Road. The farm later expanded across the road on land formerly owned by Helen S. Lawson and John L. Childs. The new lands owned by son Robert and his wife, Janet, were named Bull Run Farm, and the family operated a farm stand that was always well visited by locals. The original 1850s Victorian farmhouse, shown here, was demolished not that long ago.

FARMYARD AND BARNS, C. 1920. This view was taken on Mills Pond Road near the original Elderkin Farm. This may be the land that the Elderkins acquired on the west side of the road to expand their farming operations.

HAYING TIME, ST. JAMES, C. 1915. This scene was repeated again and again across Long Island. Haying time, which began in June, was a period to gather all the necessary foodstuffs for cattle and other farm animals before fall and winter set in. Gathering the hay on schedule was important. A late start could mean lower nutritional value of the hay, insufficient to carry larger animals through the winter. (From *Long Island To-day* by Frederick Ruther, 1909.)

THE OLSEN FARM, C. 1920. The Olsen family has lived for many years on Hobson Avenue. The original farm was located on the west side of Hobson Avenue about halfway to Oak Street. It was owned by Marius (Maurice) Olsen, who had been born in Norway in 1873 and worked here as a poultry farmer. Later in life, he worked as a ships carpenter. It is amazing that the original small farmhouse seen here still stands today, although enlarged and altered. The Olsen Farm had one of the earliest deep hand-dug wells in St. James.

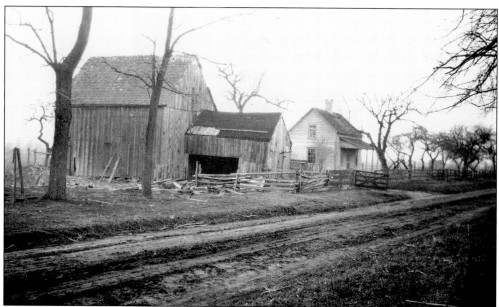

THE SULLIVAN HOUSE AND BARN, C. 1917. There were several Sullivan families living in St. James during the first quarter of the 20th century. Many were Irish immigrants and most worked as farm laborers or had a profession, such as being a carpenter. Most of them lived either on Harbor Road, Moriches Road, or Nissequogue Road. This image captures what a typical home and farm complex looked like during the period.

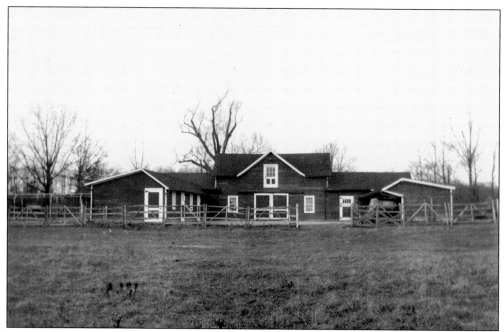

THE MCLEAN COW BARN, C. 1940. Located on the east side of North Country Road, this large and expansive barn serviced the needs of the McLean Estate, which was located across the road. Unlike many of its brethren, this barn still stands today. Although it once housed an antique business named Barn Yesterday, today it has been converted for use as a private residence.

Eight

THE HARBOR AND THE BEACH

Long Beach and Short Beach, the two major St. James beaches in addition to Otto Schubert Beach (formerly known as Little Africa—a name given because of its jungle-like woods and thatched-roof huts), have their beginnings in the early history of the township. As early as 1754, the town voted to erect a fence "for the preservation of the Long Beach." A few years later, in 1757, thatch beds were allotted to owners for their use. Both beaches were well established by the late 19th century. Relaxing days at the beach were often just for the wealthy who could afford to get themselves there and back in one day. Prior to the advent of the automobile, the beach was just too distant for anyone living locally to make practical use of. Once cars became affordable, beaches all over Long Island became a luxury available to all—but a great majority of the lands in St. James were held by the great estate owners. It was George S. Hodgkinson (1860–1928) who worked to make many of the beaches available to the public. He negotiated with the many estate owners who eventually turned over their lands and their rights so that the community could have greater access to the shore.

SAILING ON ST. JAMES BAY, C. 1905. The small sail-driven boats shown here were popular all over Long Island. Few locals could afford the more luxurious yachts that became the norm a few years later. This image was probably taken from near the Shore Road.

WINTER ON THE HARBOR, 1912. St. James Harbor, now more commonly known as Stony Brook Harbor, is shown here during winter. A heavy snow has covered the ground, and the bay appears to be partially frozen over.

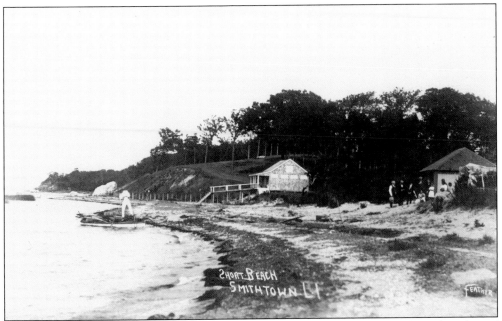

AT SHORT BEACH, C. 1914. A number of small beach cottages are shown along the edges of Short Beach. Unlike some other beaches such as West Meadow near Old Field, there were never large quantities of houses along the shore in St. James. The cleared hillside in the center background and small beach house below it are part of the extensive grounds of the Lane Estate, Suffolk House.

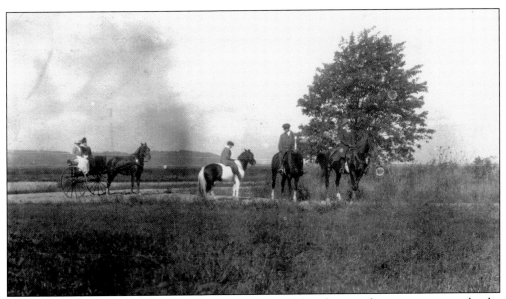

ON THE WAY TO THE BEACH, C. 1915. Before automobiles, this was the easiest way to take the rambling local roads to the beach. Small carriages and riders on horseback were preferable to the long walk some had to make to get to the shore.

BY CANOE, C. 1915. One of the activities favored by the Bacon family of Thatch Meadow Farm was to take an elaborate picnic to the small spits of land in the sound. Their cook would prepare the food and pack it into a canoe for the journey, as shown here.

AT THE BEACH, C. 1916. If one had enough time and money, a day at the beach was a wonderful event. Awnings kept the sun off. Baskets of readymade food were available. The water was clean, cool, and refreshing. Here members of the Bacon family relax on a summer day. Note the long dresses the women are wearing to preserve their creamy white skin, which was in vogue at the time.

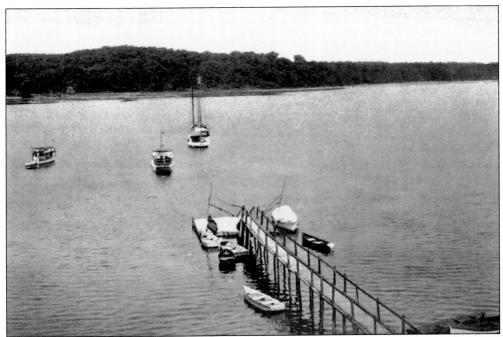

BOATS AT THE DOCK, C. 1916. The dock at Tony Farrell's Shore Inn was always filled with pleasure crafts for guests to enjoy. Here a number of small vessels are idled alongside of the dock, while others remain at anchor just offshore.

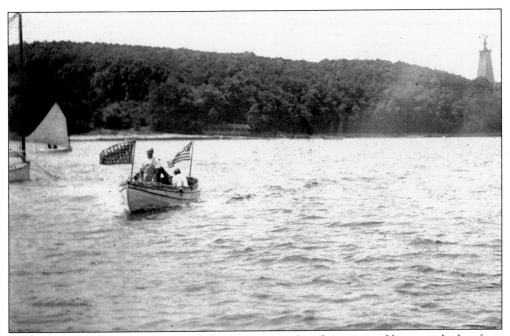

THE WAVING FLAGS, C. 1920. A small engine-powered craft moves swiftly across the bay from Nissequogue toward Head-of-the-Harbor. In the upper right background, the Butler windmill, a local landmark for decades, can be seen.

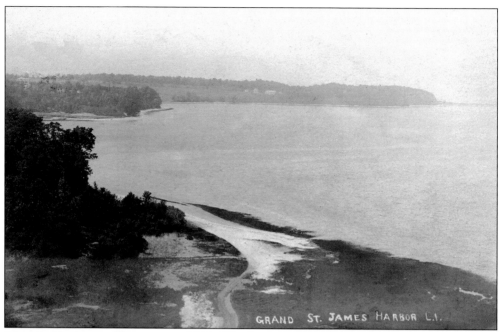

GRAND ST. JAMES HARBOR, C. 1920. The harbor was indeed a grand and awe-inspiring location. Some of the author's best beach memories are of walking out at low tide all the way into the sound on the large sandbars that appeared, although one had to be careful to return before getting trapped by the fast-returning tide.

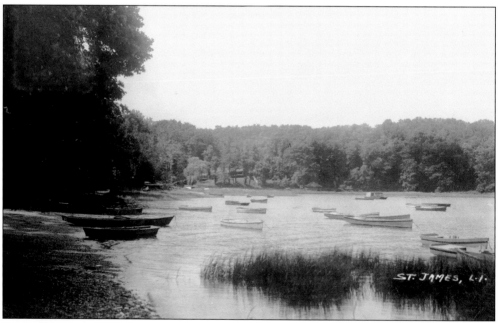

FULLY FILLED, C. 1920. Everyone who wanted to fish needed a small skiff to have around for the occasion. Fishing was a popular activity on the ponds and bay around St. James, and here one can see the many small boats moored near the shoreline, ready to go out at a moment's notice.

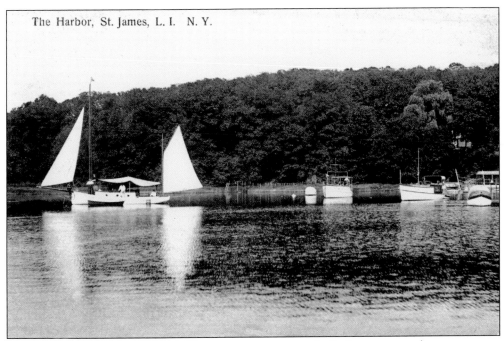

The Harbor, St. James, L. I. N. Y.

YACHTING ON THE BAY, C. 1925. The many estate owners in St. James meant there were many private yachts in the nearby waters. Here those powered by sail mingle with those powered by engines. The pleasure craft at the far left of the image is unusual in its oddly arranged rigging and sun cover.

A BOULDER AT THE BEACH, C. 1927. It has been, and probably always will be, a rite of passage for young men to make the climb to the top of the large rocks that dot the coastline of Long Island—a climb that is always easier going up than it is coming down. Here a young boy stands in front of a rock (possibly the one near Short Beach) while perhaps his mother poses for a shot on top.

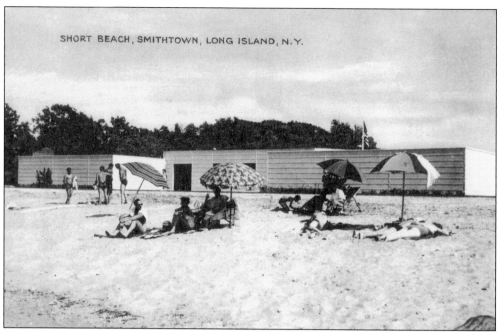

MODERN TIMES AT THE BEACH, C. 1940. The large pavilion at Short Beach was a dramatic improvement to the days of traveling to and from the house for the basics. The wooden pavilion shown here was replaced by the present brick one around 1970.

BEACH GOERS AT LITTLE AFRICA, C. 1932. Young men and women enjoy a day at the beach and prepare to do a little canoeing. Little Africa, which received its name from the thatched-roof huts that stood on stilts and the dense and tropical-looking undergrowth around the beach, was later renamed Otto Schubert Beach. Grouped around the canoe named *Pickled Herring* are A. Seaver Sr., W. Jones, Junior Jones, Gene Miller, Bill Miller, A. Seaver Jr., Phyllis D., Lester Spahr, and Marjorie D.

Nine

LEISURE TIME

Every community has those places that instill a feeling of rest, relaxation, and plain old fun. In St. James, baseball was the favorite sport with fields all over the community. Gaynor Park opened in 1937 to great fanfare and is often considered the only park St. James has ever had. That is not true. There was at least one other now vanished park on the east side of the village, in addition to the beach parks and the later Moriches Road Park. Hunting was extremely popular, both privately and at sanctioned clubs such as the Wyandanch Club in Smithtown. The Smithtown Hunt, modeled on the traditional English fox hunt, was one of the most popular activities for the privileged classes. The many balls held by the wealthy to support regional and community groups helped round out the long summers. Other activities, such as Boy Scout meetings, a ride out in a car (adventurous for the early 20th century), or resting in a comfortable hammock must seem very similar to the leisure time activities of today.

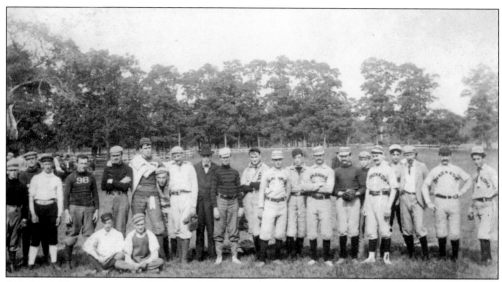

BASEBALL TOURNAMENT, 1896. Baseball became popular on Long Island very early on. St. James, with its open space, had a ball field in nearly every neighborhood. One of the largest was created by the Barry and Bowe families—both blessed by lots of baseball-loving boys—near the present-day Dairy Barn. Neighboring villages often organized amateur teams to play each other. The average man and the famous "Gentleman Jim" Corbett (1866–1933) played here with the locals. The St. James team (left), without professional-style uniforms, is shown standing with the Ronkonkoma team a few years before the dawn of the 20th century.

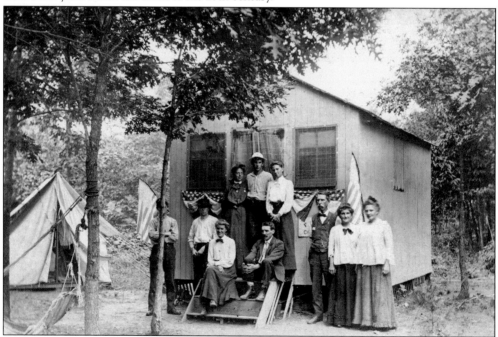

A SUMMER COTTAGE, 1906. Enjoying the natural splendor of Long Island became a time-honored tradition for those who spent their vacations here. Small bungalows and summer cottages sprang up all over. In this image, vacationers pose in front of their little summer home, while a tent and hammock are at the ready nearby.

**Out for a Ride,
c. 1910.** Everett Smith
(1859–1940) and his
guest prepare to jot off
for a quick tour around
the countryside in his
automobile. Everett
was the brother of
Livingston Smith, the
former district attorney
for Suffolk County.

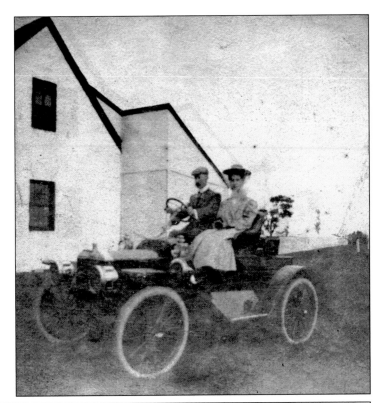

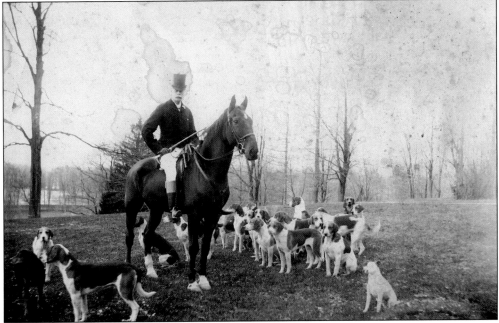

Hounds and the Hunter, c. 1912. A member of the Bliss-Lane family poses with his hunting dogs in full dressage. The Smithtown Hunt, along with the horse show, was one of the largest social activities to take place in St. James. The hunt was established in 1900 and is today the only remaining hunt club on Long Island.

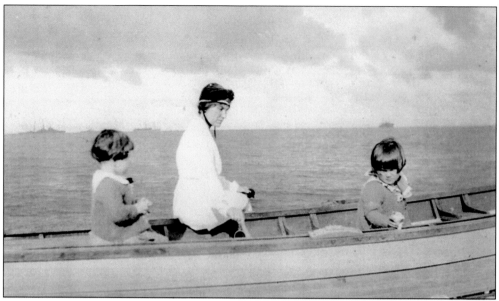

IN THE BAY, 1918. Members of the Thieriot family enjoy an outing in a small craft. In the background are several warships that were posted off the coast of Long Island during World War I.

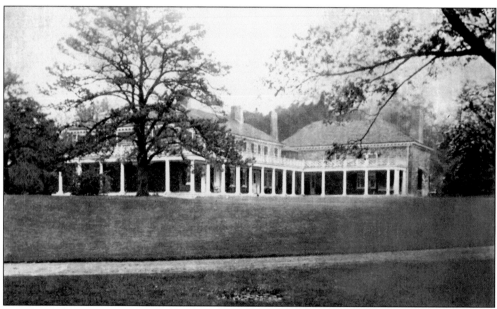

THE BUTLER CASINO, C. 1920. Designed by McKim, Mead, and White, this large structure was originally used as the playhouse and casino for the expansive Prescott Hall Butler estate. The large ballroom contained in the building became the traditional location for the much anticipated annual Smithtown Hunt Ball. The north wing was originally the squash court. A service wing was added in 1905, and the entire building was eventually converted to residential use.

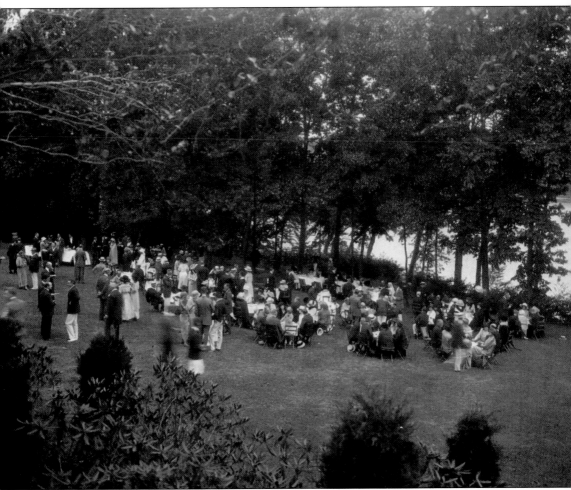

AT THE BARBECUE, 1920. For estate owners, lavish parties and spectacles were part of daily life. This image depicts a barbecue on the grounds of the Thornton Playhouse, also known as the Little Theater. There are more than 200 people depicted in this image, including the servants and footmen who are wearing their formal uniforms with tails.

A Backyard, c. 1920. The backyard shown here belonged to the Quist family. Peter Quist was a Swedish immigrant who made his living as a carpenter. He lived on Jefferson Avenue and could look forward to the old rocking chair or mounted swing for relaxation after a hard day's work.

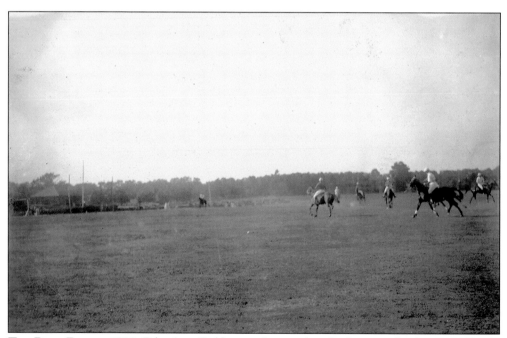

The Polo Fields, 1923. Fifty Acre Field not only served as the location for the annual horse show, but it also hosted the gentleman's sport, polo. Here participants play in a tournament on the field in 1923.

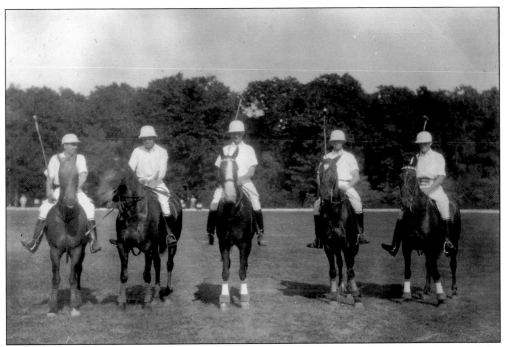

THE POLO TEAM, 1923. Scenes of polo at St. James are rare even though the playing of the game was not. Here participants pose for a group shot.

THE PRINCE'S BALLROOM, C. 1940. One of Alice McLean's great pleasures was mingling with the right people. To that end, she proposed a lavish ball and party in honor of the Prince of Wales during his official visit in 1924. She commissioned the construction of the ballroom, located on her estate along Thompson Hill Road. The ballroom, pictured here, never hosted the prince and is today just a faded memory itself.

MARCHING BOY SCOUTS, 1957. The Boy Scouts (Troop 7) were always an important part of the community. They are shown here on the march, passing by the Nissequogue Hotel and the large billboards that were long a fixture on Railroad Avenue. The Nissequoge Hotel hosted a number of community groups, including the Odd Fellows, who met on the second floor.

Ten

THE HORSE SHOW

The Smithtown Horse Show was the premier social event of the season in St. James. The show first took place in 1909 and was such a success that it became part of the regular horse-related activities each season thereafter. In its early years, the show was considered much more prestigious than other shows such as those that took place in the Hamptons and included participants of Mayor William J. Gaynor's family and a young Jacqueline Bouvier who entered as a child (1939). A rift began in the 1930s between those who favored a more traditional show versus individuals interested in expanding and modernizing the show. Not long after, the show was broken up into the North Shore Horse Show and the Smithtown Horse Show. The last local horse show took place in 1981. For the first decade or so, the Butler family kept detailed albums containing maps, press information, and many photographs of the Smithtown Horse Show. This was only natural as the Fifty Acre Field, where the show took place, was part of the holdings of the family. These early images help people understand how the show grew in size, popularity, and stature.

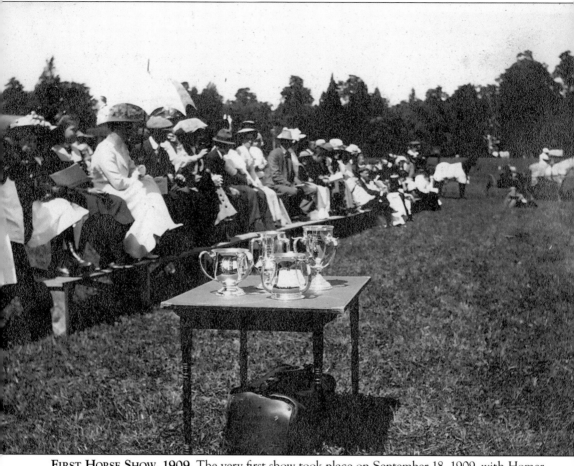

FIRST HORSE SHOW, 1909. The very first show took place on September 18, 1909, with Homer W. Reboul as its first president. In this image, members of the public sit on raised stands before the small trophy table. The trophies given out at the show became prized possessions for competitors. One of the New York City papers commented upon the first show, "Judging by the number and the quality of the entries and the enthusiastic support given the show, the officers of the association have reason to feel proud of this the maiden effort." This initial success helped make the show a staple of the community for decades to come.

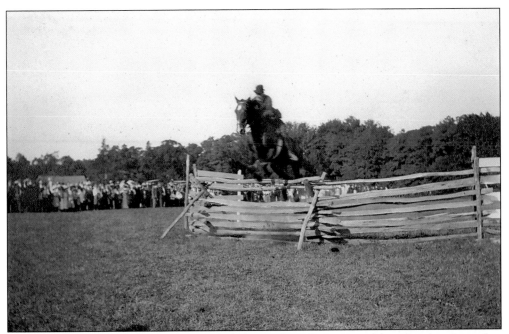

JUMPING, 1909. The first horse show included a number of activities, although as in many other shows, jumping was one of the most popular events of the day. Here a participant leaps over a rail fence during the competition. Over 2,000 individuals attended the very first horse show and partook of its 14 classes of competition.

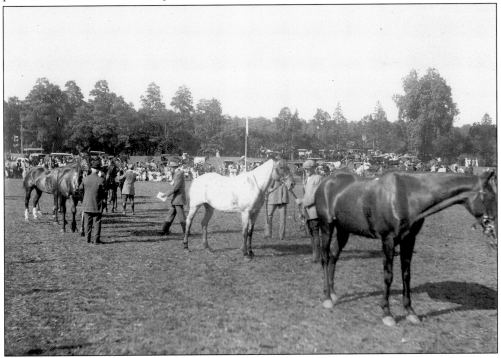

INSPECTING THE HORSES, 1911. Judges wander with their paperwork as they inspect horses at the 1911 horse show.

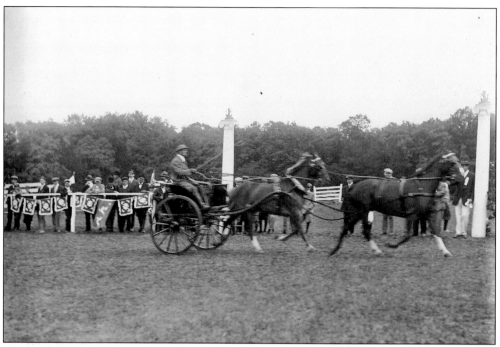

CARRIAGE PAIRS COMPETITION, 1912. This competitor rides in front of the formal entrance gate of the show marked by a pair of fluted columns with Ionic capitals and topped with rampant lions. By 1912, the fourth year of the show, classes had jumped from 14 to 25.

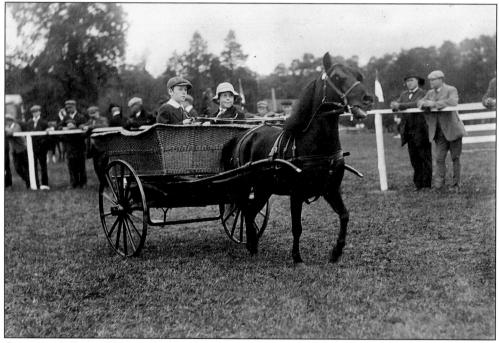

CHILDREN'S PONY COMPETITION, 1912. Two young boys display their abilities in their basket phaeton with the family pony. Children's activities were a part of the show from the very beginning when they competed in the class Ponies in Harness.

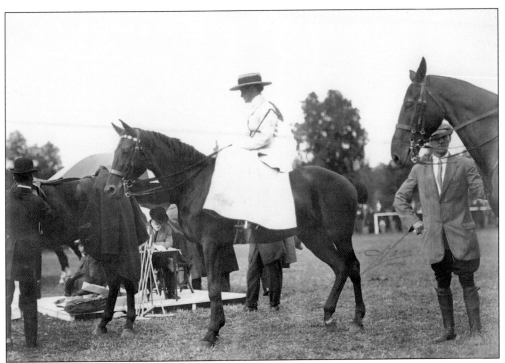

THE JUDGING STAND, 1912. Ford, Butler, and Oliver (the architectural firm that Lawrence S. Butler was a partner in) designed the layout for the show including the location of the judges' stand. Here judges inspect participant's mounts under an umbrella located at the center of the horse ring.

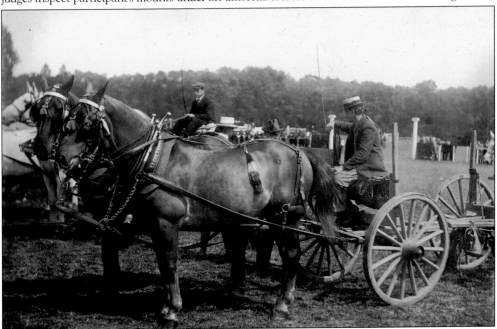

FARM HORSES, 1913. Since the show's inception, the judging of farm horses was considered important as so many local estate owners had fully functioning farms. Early entries in this category included horses owned by the Butler, Gaynor, and Emmett families.

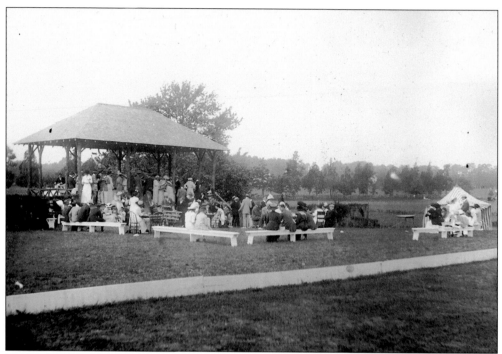

THE BANDSTAND, 1913. The bandstand, to be used for musical and other celebratory activities, was located to the right of the entrance columns. Here visitors enjoy each other's company while resting in the shade provided by the pavilion.

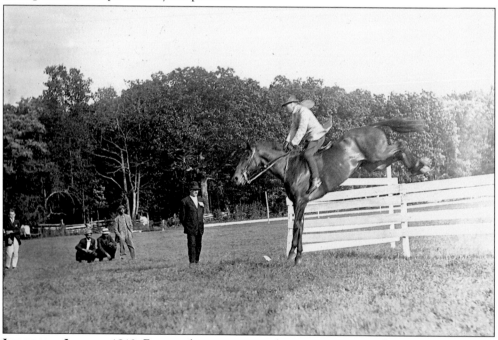

JUDGING A JUMPER, 1913. Form and manners were the two categories to be considered heavily in judging jumpers, whether they be lightweight or heavyweight. Note the old, raw split-rail fence has been replaced with a more formal and detailed fence structure.

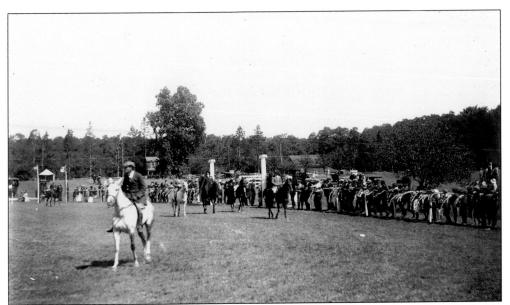

A VIEW OF THE RING, 1914. The main ring was encircled by stands and viewing areas for the public while the area just beyond was used for parking carriages and automobiles. Participants are shown riding around the main ring with the entrance columns in the center background.

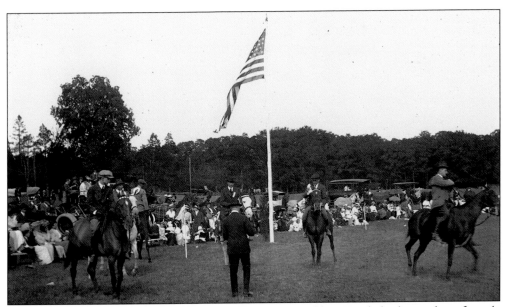

AROUND THE FLAGPOLE, 1914. Horses and riders assemble around the horse show flagpole while many seated visitors look on. It was at this event that show official Alfred Knapp was kicked in the head by a horse and rendered unconscious. Fortunately he made a full recovery.

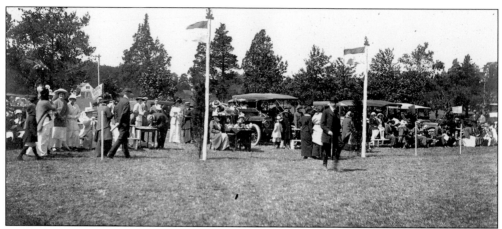

AT REST, 1914. Between competitions, visitors could rest in the seating area or promenade around the outer edge of the main ring. Some in this image are enjoying refreshments at small portable tea tables while their large automobiles are parked behind them. According to the *New York Times*, an unusual "comparison" was made at this show when "L. Hostings Arnold drove his four-in-hand on the grounds with a large number of guests, for of the hundreds of vehicles parked outside the show ring the four-in-hand was the only horse-drawn one in the gathering!"

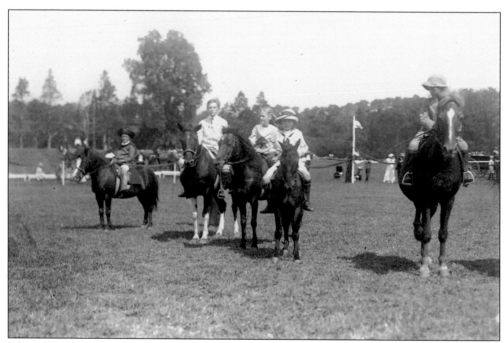

"OUR TURN!" 1915. Every child always wants to do what his parents get to do. At the horse show, this was the rule rather than the exception. Here a number of local children are ensconced aboard their ponies ready for competition.

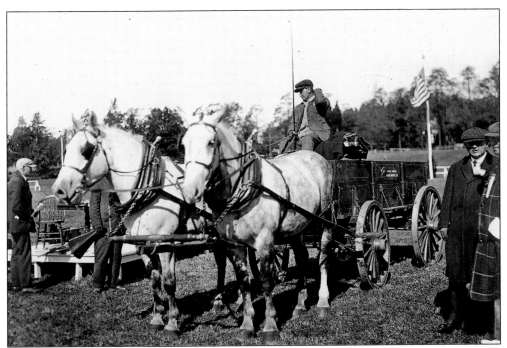

FARM HORSE COMPETITION, 1916. A magnificent farm wagon and team belonging to George E. Gould, born in 1865, of Lake Grove readies for competition at the show.

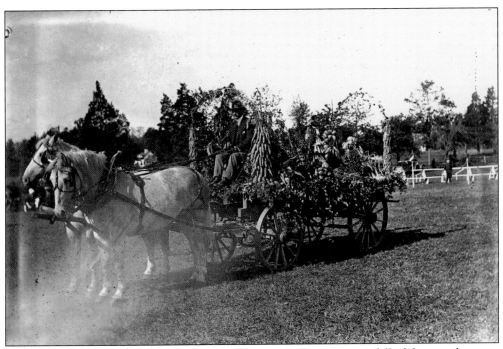

WAGON DISPLAYS, 1916. Each year local farmers would decorate carts full of their produce as a display of their success. In this photograph, a cart is covered with all sorts of vegetables, including yams, leeks, beans, apples, berries, and so on. These carts were almost mobile horns of plenty.

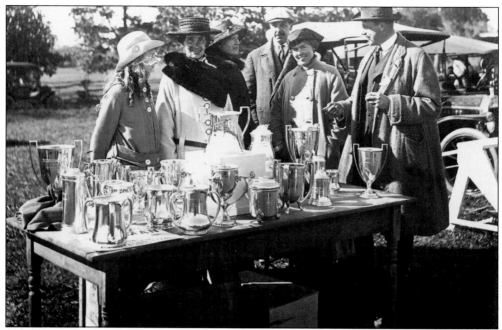

THE TROPHY TABLE, 1916. By 1916, the trophy table had been considerably enhanced. The many boxes, cups, vases, and other awards shown here, made of both sterling silver and silver plate, wait to be presented to each category's winner.

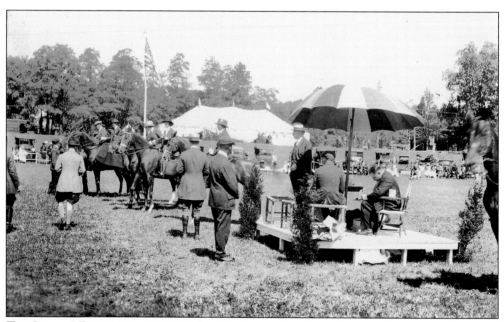

THE JUDGES' PLATFORM, 1919. Much of the horse show's activity may have occurred up and around the ring, but its most essential activity, that of scoring and judging, took place at its center. Here, under a sun-blocking umbrella, judges could tally their scores without interruption. By this point, the deck on which they sat had acquired fancy shrubs at the four corners to help further enhance their status. In the background a large tent has been erected for use at the show.

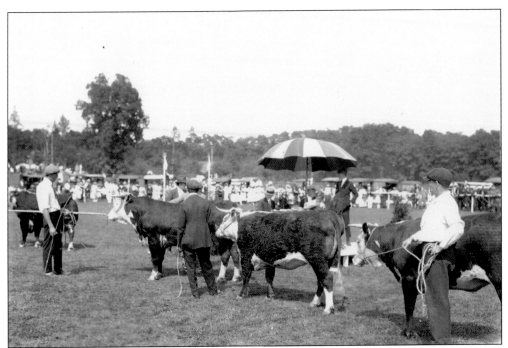

THE LIVESTOCK ARRIVES, 1921. Cattle were part of the show this year, a departure from the very first show. Here they are marching into the ring single file to be viewed by all. Nearby Ebo Farm on Edgewood Road (later avenue) had some of the finest Hereford cattle in the United States at that time.

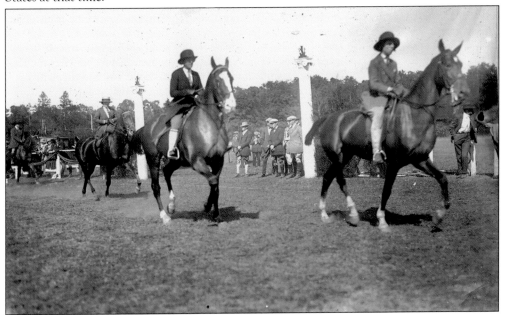

LADIES RIDING, 1922. Ladies Saddle Horses was a class in the very first horse show and remained popular over the years. Here a group of young ladies march past the entrance gate readying for their moment in the limelight. By the 1920s, both polo and breeding classes had been added to the show.

BIBLIOGRAPHY

Beers, F. W. *Atlas of Long Island, New York from Recent and Actual Surveys and Records*. New York: Beers, Comstsock, and Cline, 1873.

Belcher-Hyde, E. *Atlas of a Part of Suffolk County, Long Island, New York, North Side–Ocean Shore*. New York: E. Belcher-Hyde, 1902, 1909, 1917.

The *Brooklyn Daily Eagle*, 1841–1902.

Chace, J. Jr. *Map of Suffolk County, Long Island, New York*. Philadelphia: John Douglass, 1858.

Chapman Publishing Company. *Portrait and Biographical Record of Suffolk County, Long Island, New York*. New York and Chicago: The Chapman Publishing Company, 1896.

Churches of St. James. St. James, New York: Saint James Methodist Church, 1966.

Deutzman, Marion Howell. *Reminiscences—St. James Pre-World War II*, c. 1986. Unpublished manuscript, copy held by the Smithtown Library, Smithtown, New York.

Fiftieth Anniversary—Loyal Lodge No. 252. St. James, New York: Sons of Norway, 1974.

Ganz, Charlotte Adams, ed. *Colonel Rockwell's Scrap-book*. Smithtown, New York: Smithtown Historical Society, 1968.

Gish, Noel J. *Smithtown, New York 1660–1929—Looking Back Through the Lens*. Virginia Beach, Virginia: The Donning Company, 1996.

Harris, Brad. *A History of the Hamlet of St. James*. Smithtown, New York: The Smithtown News, c. 1980s, copy held by the author, St. James, New York.

———. *News of Long Ago*. Smithtown, New York: The Smithtown Messenger (articles on local history), c. 1980–1987, copies held by the author, St. James, New York.

Hazelton, Henry Isham. *The Boroughs of Brooklyn and Queens, Counties of Nassau and Suffolk, Long Island, New York, 1609–1924*. Five Vols. New York and Chicago: Lewis Historical Publishing Company, 1925.

http://www.ibdb.com

http://www.imdb.com

Katz, Anne. *A Study of St. James, New York*. Unpublished manuscript, 1976, copy held by the Smithtown Library, Smithtown, New York.

Langhans, Rufus B. *Place Names in the Town of Smithtown—Their Location, Origin and Meaning*. Smithtown, New York: The Smithtown Library (Handley Series), 1961.

Larocca, Margaret A. *Environmental and Historical Study of St. James, Long Island*. Unpublished manuscript, 1981, copy held by the Smithtown Library, Smithtown, New York.

Lewis Publishing Company. *Long Island: A History of Two Great Counties: Nassau and Suffolk*. Three vols., New York: Lewis Publishing Company, 1949.

Long Island and Where to Go! New York: Lovibond and Jackson, 1877.

The Long Island Association. *Long Island: The Sunrise Homeland 1954*. Patchogue, New York: The Long Island Association, 1954.

A Look at Our Community. St. James, New York: St. James Methodist Church, 1960.

Mather, Frederic G. *The Refugees of 1776 from Long Island to Connecticut*. Albany, New York: J. B. Lyon and Company, 1916.

McCroskey-Reuter. *St. James Business Improvement Plan*. Smithtown, New York: Town of Smithtown, 1983.

More About Life in St. James. St. James, New York: Saint James Methodist Church, 1962.

Naylor, Natalie A., ed. *Journeys on Old Long Island—Travelers' Accounts, Contemporary Descriptions, and Residents' Reminiscences 1744–1893*. Interlaken, New York: Empire State Books (in association with Hofstra University), 2002.

The *New York Times*, 1851–present.

Pickett, Herbert Jr. *A Short History of Hyde Bay Camp For Boys*. http://www.hydebay.net

Saint James Area Maps. Unpublished, c. 1910–1970, copies held by the author, St. James, New York.

St. James Church 1853–1953. St. James, New York: St. James Episcopal Church, 1953.

Saint James General Store 1905–1919: A Community Portrait. Unpublished Manuscript, c. 1990, copy held by the Smithtown Library, Smithtown, New York.

St. James Past and Present. St. James, New York: Saint James Methodist Church, 1963.

The St. James United Methodist Church. St. James, New York: Saint James Methodist Church, 1969.

Sts. Philip and James Parish Celebrates 75 Years. St. James, New York: Sts. Philip and James Catholic Church, 1982.

A Salute to the St. James Fire Department. St. James, New York: St. James Methodist Church, 1964.

Shopsin, William C. and Marcus, Grania Bolton. *Saving Large Estates*. Setauket, New York: Society for the Preservation of Long Island Antiquities, 1977.

Smith, Frederick Kinsman. *The Family of Richard Smith of Smithtown, Long Island*. Smithtown, New York: The Smithtown Historical Society, 1967.

Smith, J. Lawrence. *The History of Smithtown*. Smithtown, New York: The Smithtown Historical Society, 1961.

Smithtown Building-Structure Inventory Forms. Albany, New York: Division for Historic Preservation, New York State Parks and Recreation, c. 1978–1980, copies held by the Smithtown Library, Smithtown, New York.

Smithtown Horse Show Program Collection. Originals held by the Smithtown Library, Smithtown, New York, c. 1909–1970.

Smithtown Horse Show Research Collection. Unpublished Photograph Albums, c. 1909–1923, originals held by the Smithtown Library, Smithtown, New York.

Van Liew, Barbara. *Fifty Years 1920–1978—Head of the Harbor, Suffolk County, New York*. New York: The Village of Head-of-the-Harbor, 1978.

———, and others. *Head-of-the-Harbor—A Journey Through Time*. Laurel, New York: The Village of Head-of-the-Harbor, 2005.

———. *Village of Head-of-the-Harbor Historian's Research Files*. Unpublished, c. 1970–2000, copies held by the Village of Head-of-the-Harbor, New York.

Villa Memo Signature Book, 1911–1941. Unpublished, copy held by the author, St. James, New York.

Wedding Signature Book of Frances Thieriot, 1912. Unpublished, copy held by the author, St. James, New York.

Wells, Betty Tuthill. *Robins Island Reflections: 1639–2001*. Sevierville, Tennessee: Insight Publishing Company, 2001.

White, Samuel G. *The Houses of McKim, Mead, and White*. New York: Rizzoli International Publications, 1998.

Yates, Stephen. *Fire Insurance Estimate—Estate of Alice T. McLean, St. James, N.Y.* Unpublished manuscript, 1940, copy held by the author, St. James, New York.

Discover Thousands of Local History Books Featuring Millions of Vintage Images

Arcadia Publishing, the leading local history publisher in the United States, is committed to making history accessible and meaningful through publishing books that celebrate and preserve the heritage of America's people and places.

Find more books like this at
www.arcadiapublishing.com

Search for your hometown history, your old stomping grounds, and even your favorite sports team.

Consistent with our mission to preserve history on a local level, this book was printed in South Carolina on American-made paper and manufactured entirely in the United States. Products carrying the accredited Forest Stewardship Council (FSC) label are printed on 100 percent FSC-certified paper.

MADE IN THE USA